FLOWERS
FOR A
FRIEND

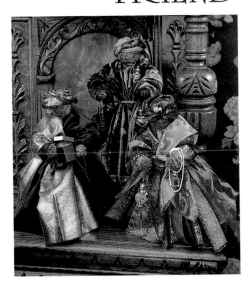

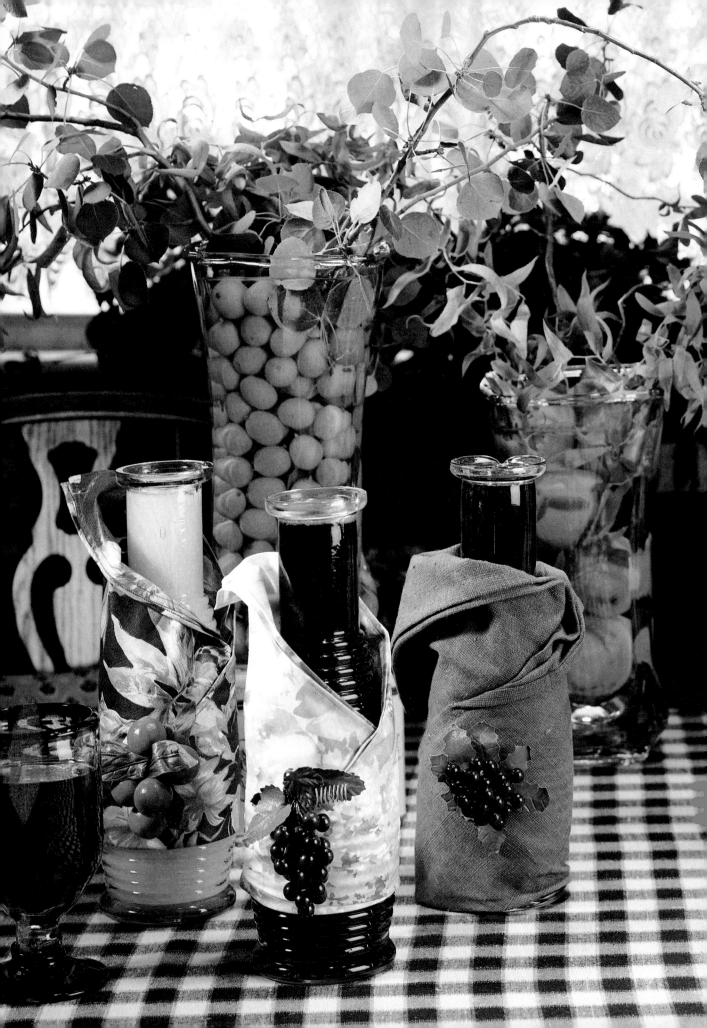

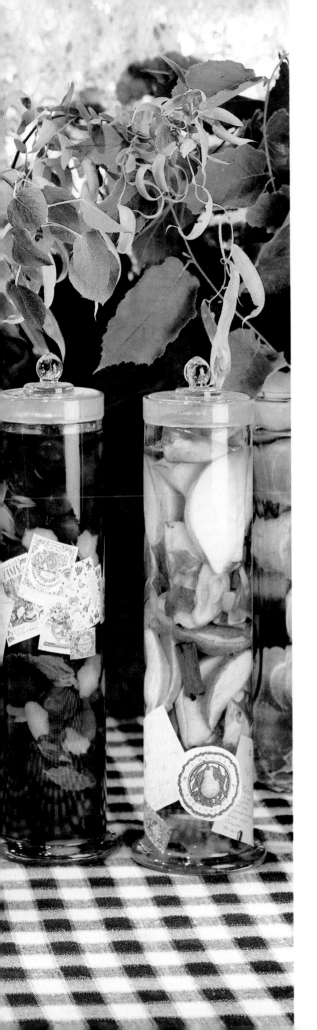

FLOWERS
FOR A
FRIEND

by The Vanessa–Ann Collection

Meredith® Press
New York, New York

For Meredith® Press

Meredith® Press is an imprint of Meredith® Books

President, Book Group
Joseph J. Ward

Vice President, Editorial Director
Elizabeth P. Rice

Executive Editor
Connie Schrader

Editorial Project Manager
Jennifer Darling

Production Manager
Bill Rose

For Chapelle Ltd.

Owners
Terrece Beesley and Jo Packham

Staff
Trice Boerens
Tina Annette Brady
Sandra Durbin Chapman
Holly Fuller
Kristi Glissmeyer
Susan Jorgensen
Margaret Shields Marti
Jackie McCowen
Barbara Milburn
Lisa Miles
Pamela Randall
Jennifer Roberts
Florence Stacey
Nancy Whitley
Gloria Zirkel

Designers
Diana Dunkley
Donene Jones
Jo Packam
Jennifer Roberts
Florence Stacey
Trends & Traditions
Barbara VandanBosch

Photographer Ryne Hazen

Dear Crafter,

We're pleased to present to you *Flowers for a Friend*, a very special craft book from the creative designers at The Vanessa-Ann Collection.

Within these pages are more than 80 winsome projects featuring fresh and dried flowers. Wreaths, baskets, picture frames, and holiday decorations are only a few of the many enticing choices you'll find.

We at Meredith® Press strive to bring you the highest quality craft books, with fine designs, innovative uses for your creations, clear instructions, and full-color photographs showing each project. We truly hope you'll enjoy *Flowers for a Friend*.

Sincerely,

Jennifer Darling

Jennifer Darling
Editorial Project Manager

Photographs in this book were taken at Penelope Hammons' home, Layton UT; Jo Packam's home, Ogden UT; Edie Stockstill's home, Salt Lake City UT; Anita Louise's Bearlace Cottage, Park City UT; and Mary Gaskill's Trends & Traditions, Ogden UT. Their cooperation and trust are deeply appreciated.

ISBN: 0-696-02383-0
LOC: 92-085485

Published by Meredith® Press
Distributed by Meredith® Corporation, Des Moines IA.
10 9 8 7 6 5 4 3 2 1
All rights reserved.
Printed in the United States of America.

To my son: You are my endless joy
and the anchor of my life.
I love you.

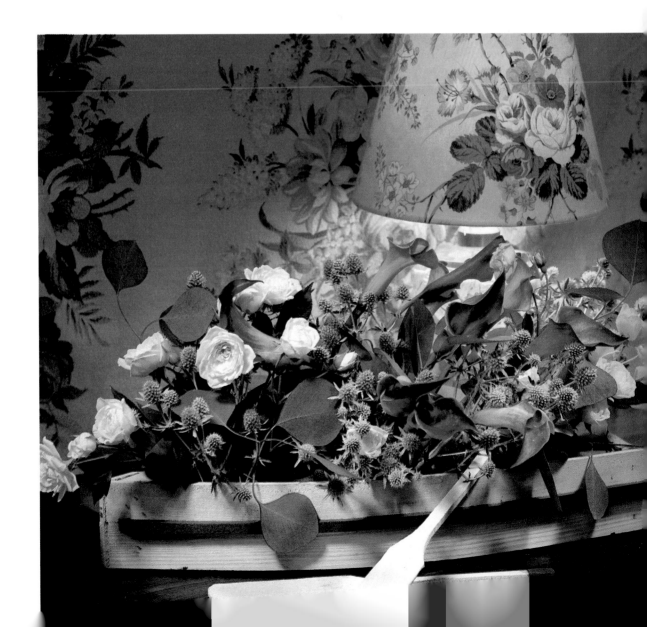

Contents

The Circle Is Unbroken
(dazzling floral wreaths)

Every Day's A Holiday
(celebrating with flowers)

General Instructions

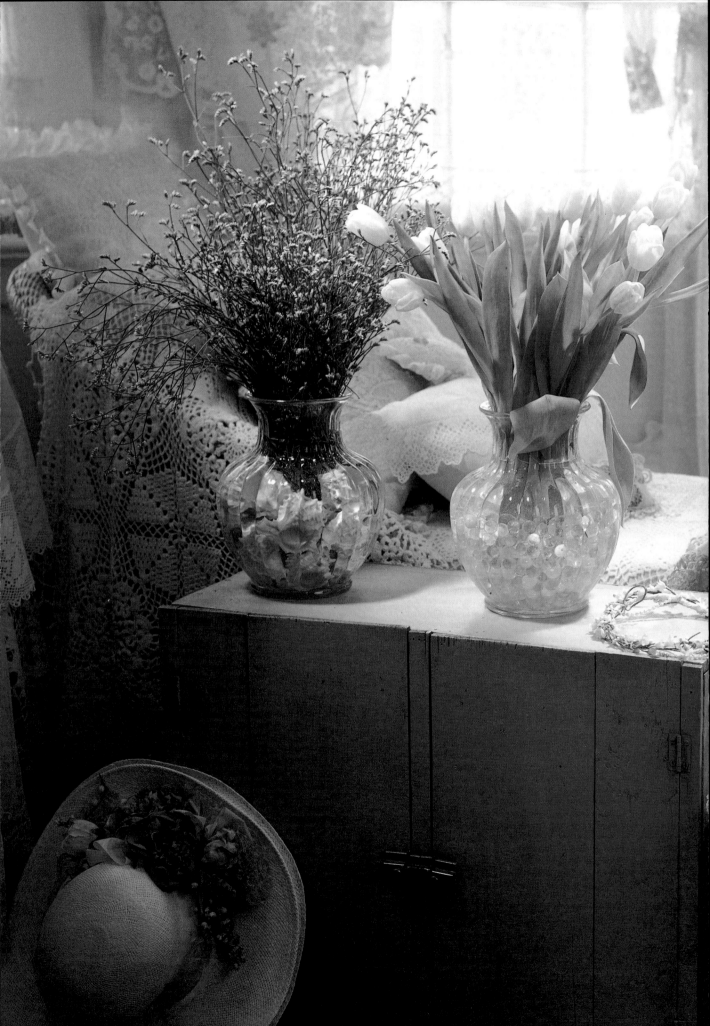

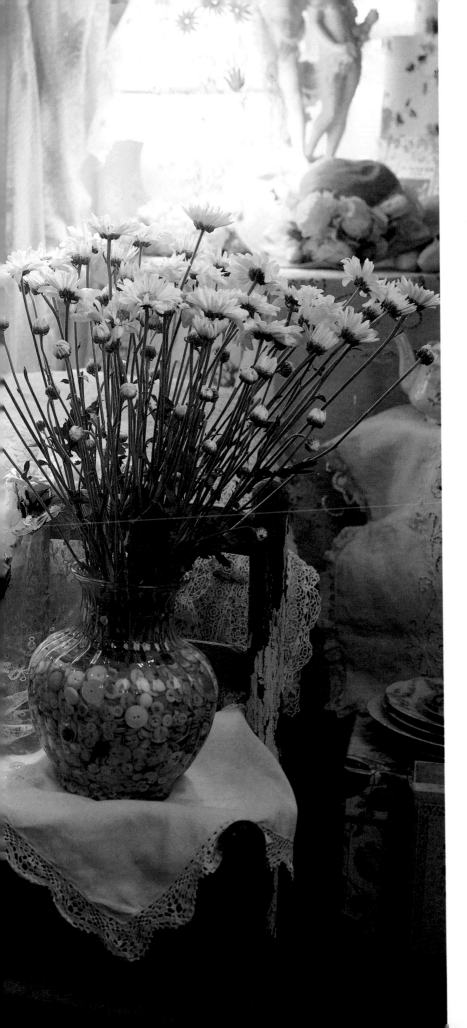

To Have
& To Hold

A meadow alive with aromatic blossoms, dancing petals and spirited colors cannot be contained. But the brilliance can be held for a moment or more in a vase, a basket or a clay pot. Capture the beauty, bring sunshine indoors and welcome a new friend.

Assembled with Mother Nature in mind, these Crystal Clear Vases complement nature's gifts and show off personal treasures. Fill vases with sea shells, marbles or buttons. Add water. Then insert an armful of sunny statice, fresh-faced tulips or eager daisies.

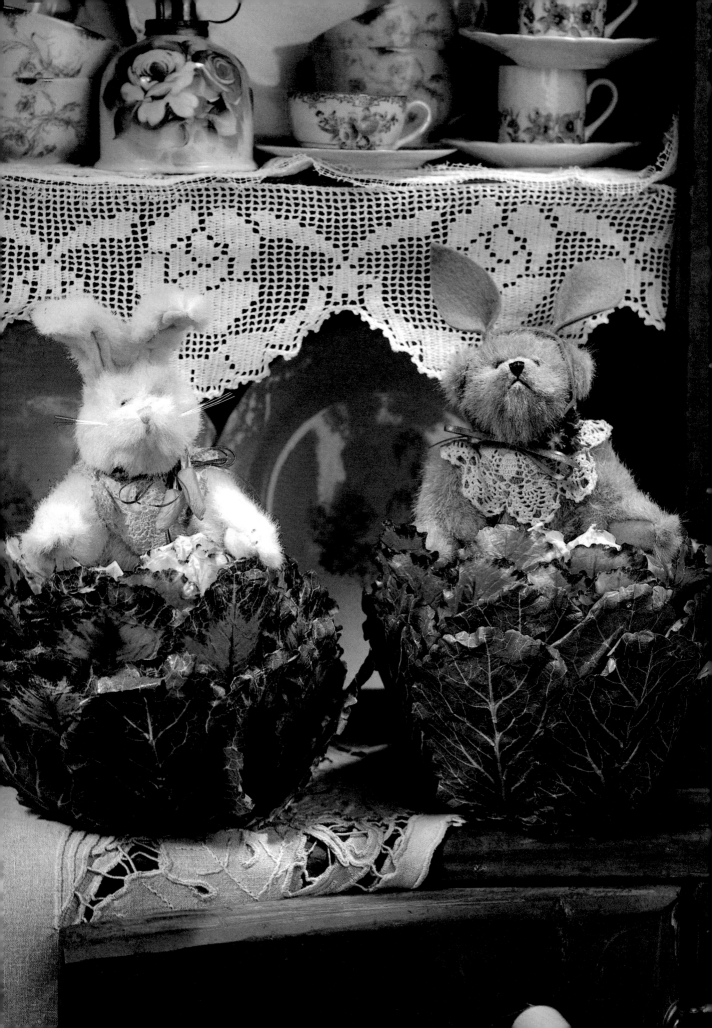

Cabbage Patch Surprise

Two 4" x 6½" glass bowls
Six silk cabbage heads
10" purchased stuffed bear
10" purchased stuffed bunny
3" x 12" piece of tan felt
Two 3½" cream crocheted doilies
Dried purple straw flowers
Two purchased crepe-paper carrots
14" length of ¹⁄₁₆" brown silk ribbon
¾ yard of ¹⁄₁₆" green silk ribbon
Two tea bags
Two sheets green tissue paper
Hot glue gun and glue sticks

1. Tea-dye doilies. Put two tea bags in a small bowl of warm water. Place doilies in water until desired color. Take from water and allow to dry.

2. Pull cabbage apart to make individual leaves. Starting 1" below top rim of bowl, glue two rows of small leaves. Working to base of bowl, continue gluing and overlapping leaves in graduated sizes; see photo. Repeat with second bowl and remaining leaves.

3. To make rabbit ears for bear, trace ear pattern. Transfer to felt and cut two. Also cut one 1" x 5" felt strip. Stitch dart in bottom of felt ear. Repeat with other ear.

4. To make slits for bear's ears, measure ⅝" from one short edge of felt strip; mark. Cut ½" slit at mark, parallel to long edge. Glue felt rabbit ear ⅛" from slit. Repeat with opposite edge of felt strip and remaining ear.

5. Poke small hole in each short edge of felt strip. Cut brown ribbon in half. Pull one half through hole, tie knot in end and glue at hole. Repeat with remaining ribbon and hole. Place strip on bear's head, pulling ears

through slits. Tie free ends of ribbon into bow around bear's neck.

6. Cut two doilies (see Diagram). Glue one around bear's neck and whipstitch raw ends together to close. Glue straw flowers to left top of doily. Glue remaining doily around rabbit's neck; whipstitch. Tie green ribbon into bow around rabbit's neck and glue paper carrots at bow center.

7. Place tissue paper in one cabbage bowl and bear on top of tissue paper. Repeat with rabbit and remaining cabbage bowl.

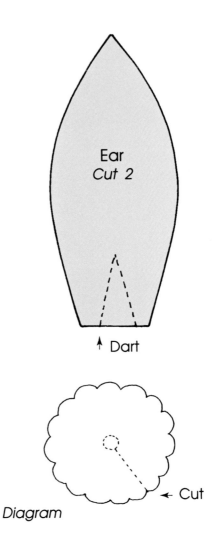

Ear
Cut 2

↑ Dart

← Cut

Diagram

Floating Fresh Flowers

Wood toy sailboat and oars
3" round plastic container
Two 2½" round plastic containers
2½" round metal florist's frog
Two 2" round metal florist's frogs
Bunch fresh alfalfa clover
Fresh large eucalyptus leaves
Fresh small white roses
Fresh pink lilies

Position plastic containers in boat bottom as desired. Place corresponding-sized florist's frog into container. Fill containers with water. Using frog pronges to secure arrangement, position clover, leaves, roses and lilies in containers; see photo.

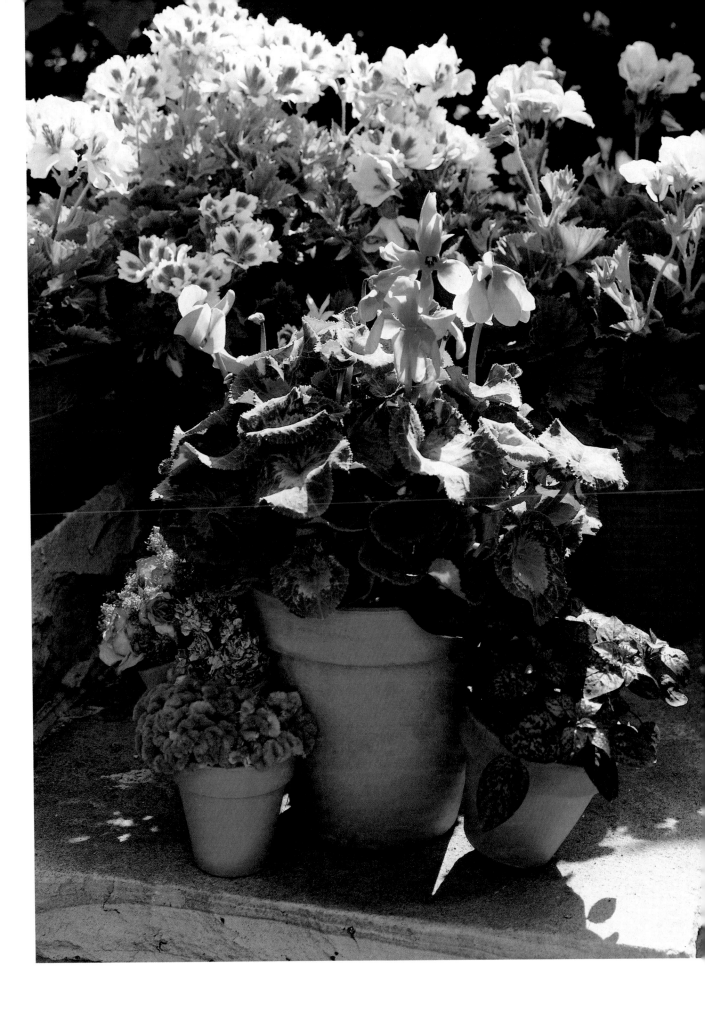

Potted Pretties

Page 13

7½" x 10" clay pot
4" x 4½" clay pot
Two 3" x 3½" clay pots
1½" x 1½" clay pot
Florist's foam
Dried purple larkspur
Dried celosia
Dried roses
Dried peppergrass
Potting soil
Live geranium
Small live houseplant
Hot glue gun and glue sticks

1. Angle and glue small clay pots to large clay pot; see photo. Glue 1½" clay pot to rim of one 3" clay pot and fill with larkspur.

2. Cut florist's foam and place in 3" clay pots. Fill one 3" pot with celosia and another with dried roses and peppergrass.

3. Place potting soil in 7½" clay pot; plant geranium. Place soil in 4" clay pot; plant houseplant.

Victorian Blooms

Provender basket
Sheet moss
Large dried green leaves
Dried red rose petals
Three dried pansies
Ten dried red roses
Ten dried white roses
Bunch dried brown eucalyptus
Small dried brown leaves
Small craft bird nest
Mushroom bird
1½ yards of 1½" pink/green silk ribbon
½ yard of 1¼" purple variegated silk ribbon
Craft-Flex lacquer
Hot glue gun and glue sticks

1. Glue moss to basket bed. Glue one layer of green leaves covering moss. Add rose petals in small circle in middle of leaves. Glue on dried pansies, partially covering rose petals on left side. Glue brown leaves, eucalyptus and roses, stacking to border basket. Glue nest to front on top of roses. Glue bird in nest.

2. Cut pink/green ribbon into three 18" lengths. Glue one end to base of basket handle. Wrap ribbon around handle; glue end to opposite handle base. Repeat with second length of ribbon, wrapping in opposite direction. With third length, tie a bow at base of handle. Near pink/green bow, tie a bow with purple variegated ribbon.

3. Pour Craft-Flex into a spray bottle and spray flowers.

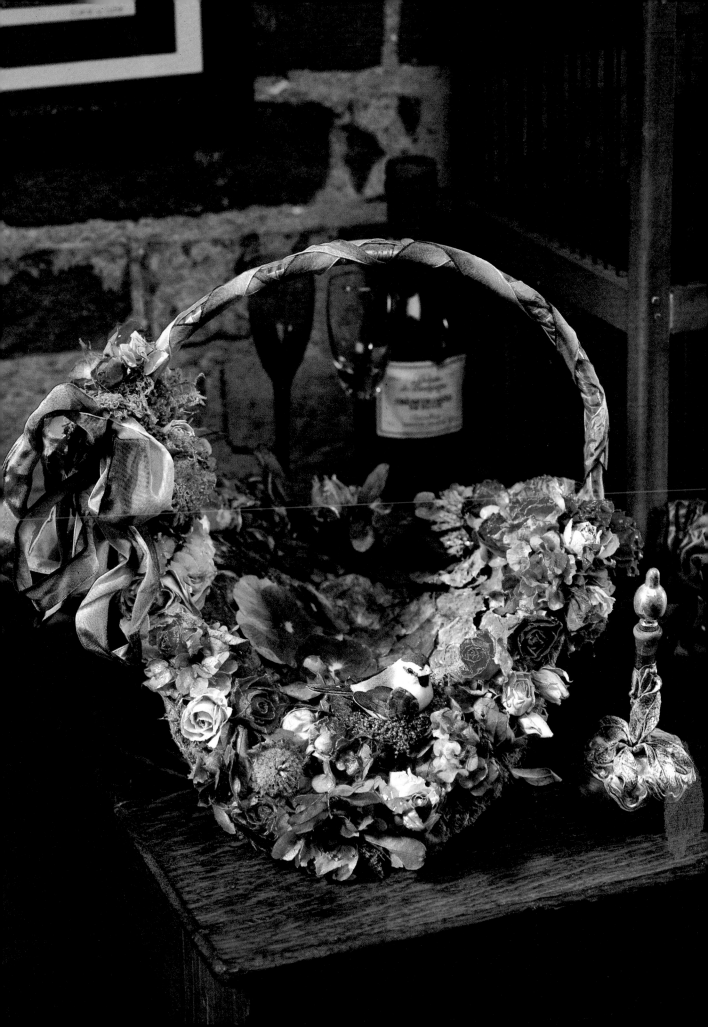

Ribbon Roses Journal

5½" x 7½" white paper-covered journal
Five green velvet leaves
1 yard of ⅞" mauve-striped wired ribbon
½ yard of ⅝" purple wired ribbon
1 yard of 1½" purple variegated wired
 ribbon
1½ yards of ½" rainbow wired ribbon
Bunch dried miniature purple berries
Four large pearl flower centers
Gold metallic paint
Sponges
Needle and thread
Hot glue gun and glue sticks

1. Sponge paint journal front and back cover with gold paint. Allow to dry.

2. Cut mauve-striped ribbon into three equal lengths. Cut rainbow ribbon into one 26" length, one 16" length and one 12" length. Cut ⅝" purple ribbon into two 9" lengths. Cut purple variegated ribbon into two 10" lengths and two 8" lengths.

3. To make snapdragons from mauve ribbon, make a ½" fold at bottom of one length. Secure by stitching with needle and thread (see Diagram A). Continue to fold ribbon, overlapping and gathering to back. Stitch to secure (see Diagram B). Repeat with remaining two lengths. Set aside.

4. To make ribbon lilies, see General Instructions on page 158. Make two 9" purple lilies and two 8" purple variegated lilies. Set aside.

5. To make ribbon roses, see General Instructions on page 158. Make one 10" purple variegated ribbon rosebud and one 12" rainbow ribbon rose. Repeat using remaining rainbow ribbon lengths to make one medium and one large rose.

6. Glue velvet leaves, mauve snapdragons, purple lilies, purple variegated rosebud and small rainbow rose to journal front; see photo. Glue pearl flower center in each lily.

7. Sew gathering threads along one long edge of 10" purple variegated ribbon piece. Gather moderately. Glue ribbon to journal front in a circle to form flower with raw edges meeting at right. Glue purple berries to middle of flower. Glue medium rainbow rose over raw edges of flower. Glue large rainbow rose; see photo.

8. Sponge paint with gold all flowers and leaves as desired. Allow to dry.

Diagram A *Diagram B*

Prissy Purple Basket

6" x 11" black wire basket
2 yards ½" purple wired ribbon
2½ yards ¾" purple wired ribbon
2 yards 1½" purple wired ribbon
2 yards 1½" green variegated wired
 ribbon
4½ yards 2" purple variegated wired
 ribbon
1½ yards 2" blue variegated wired ribbon
3 yards ⅛" pink silk ribbon
3 yards ⅛" lavender silk ribbon
4" craft foam ball
Eight mauve flower centers
1 yard lightweight white gauze fabric
Acrylic paints: blue and lavender
Paintbrushes
Fabric stiffener
Needle and thread
Tacky glue

1. Cut 12" length of ¾" purple wired ribbon and weave through handle of basket. Cut two 1-yard lengths of ½" purple wired ribbon and weave through top two rows of basket. Cut two 1-yard lengths of 1½" purple wired ribbon and weave through the next two rows. Cut two 1-yard lengths of ¾" purple wired ribbon and weave through bottom two rows of basket.

2. To make pinecones, cut craft foam ball in half. Cut one 3", one 2½" and two 2" wedges. Mold into pinecone shapes by rolling.

3. Cut 2" blue variegated and 2" purple variegated ribbon according to pinecone pattern. Cut 100 pattern pieces from blue ribbon and 300 from purple ribbon. Starting at small tip of each foam pinecone, glue ribbon

pieces one petal at a time, overlapping each row to bottom. Make one blue and three purple pinecones.

4. Cut gauze into two equal lengths. Place blue paint in a jar and thin with water. Paint one length of gauze. Repeat with purple paint and remaining gauze. Allow to dry. Spray fabric stiffener on gauze and allow to dry. Turn over and spray. Allow to dry.

5. To make flowers, cut gauze according to patterns. From blue gauze, cut six small petals for one small flower and twenty large petals for two large flowers. From lavender gauze, cut twelve small petals for two small flowers and twenty large petals for two large flowers. With straight ends meeting at bottom, pinch petals together and glue. With needle and thread, stitch flower petals together, overlapping as desired.

6. To make ribbon leaves, cut 1½" green variegated ribbon into 4" lengths and see General Instructions on page 158.

7. To make bows, cut pink silk ribbon into five equal lengths. Make several 1½" loops and glue at base. Repeat with lavender ribbon.

8. Glue pinecones, gauze flowers, leaves, flower centers and bows to basket; see photo.

Pinecone
Cut 100 blue
Cut 300 purple

Large Petal
Cut 20 blue
Cut 20 lavender

Small Petal
Cut 6 blue
Cut 12 lavender

Beaded Blossoms

3" x 7" glass vase
Three 1-yard strands of purple beads
½ yard of ⅝" purple wired ribbon
3" of ⅝" green wired ribbon
Hot glue gun and glue sticks

1. Cut purple wired ribbon into two 9" lengths. See General Instructions on page 158 to make one large ribbon rose from one 9" ribbon length and one leaf from green wired ribbon. Glue leaf to back of rose.

2. Starting at bottom of vase, wrap and glue strands of beads, covering vase to top rim.

3. Wrap remaining 9" purple wired ribbon length around middle of vase with short raw edges meeting in front; glue. Glue ribbon rose/leaf over raw edges.

Bedazzled Beauty

6" x 7½" framed oval mirror
Two 1-yard strands of purple beads
1 yard of ⅝" purple wired ribbon
1 yard of ⅝" lavender wired ribbon
Two bunches dried miniature purple berries
Hot glue gun and glue sticks

1. Cut beads off strands. Glue beads, one bead at a time, to mirror frame; see photo.

2. To make one small and two large ribbon roses from purple ribbon, see General Instructions on page 158. Also make one large and two small ribbon roses from lavender ribbon. Glue roses and berries to beaded mirror frame; see photo.

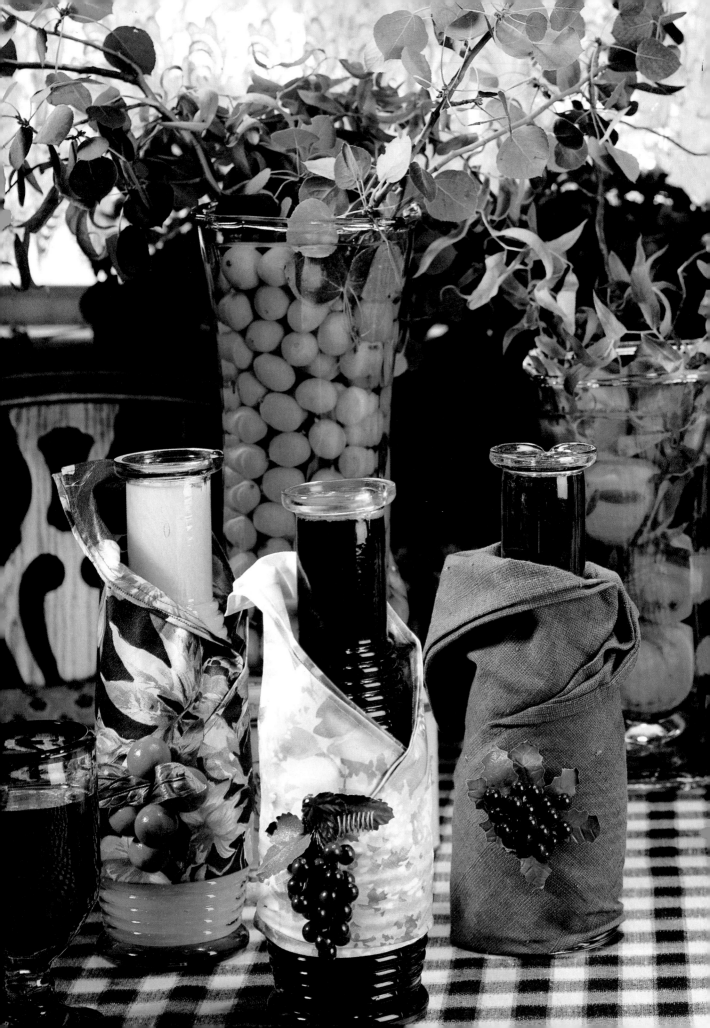

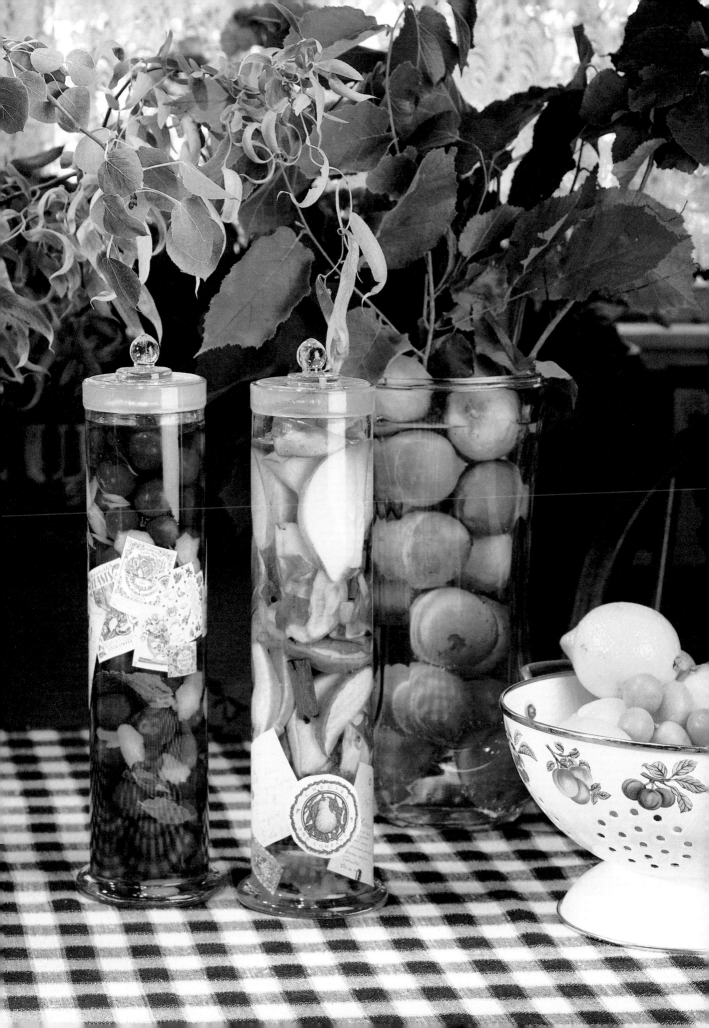

Homemade Liqueurs

Two 3" x 14" glass jars with lids
Magazine cutouts
Tacky glue

Pear Liqueur:
½ pound ripe pears
Peelings of two apples
Cinnamon stick
Whole clove
Pinch nutmeg
Two coriander seeds
1½ cups vodka or brandy
½ cup sugar

Cherry Mint Liqueur:
2½ cups cherries
Twenty fresh mint leaves
Sliced peel of ½ lemon
2 cups vodka
½ cup sugar

1. To decorate jars, cut small pictures from magazines and glue to jar; see photo.

2. For pear liqueur, slice pears and place in jar with all other dry ingredients. Add vodka or brandy to cover. Steep two weeks. Shake jar every two days to mix ingredients. Strain and filter. For sweeter liqueur, add sugar in small amounts to taste. Liqueur takes about two months to mature.

3. For cherry mint liqueur, remove stems from cherries and place in jar along with mint leaves and lemon. Add sugar, then vodka. Close jar tightly and place in sun for one week. Then set jar in a cool dark place for four weeks. Strain. Let mature at least two months.

Wrapped Juice Jars

Three 11½" x 3½" glass bottles
Three 20" square cloth napkins
Miniature plastic or silk fruit
Silk leaves
Three jewelry pin backs
Fruit juice
Hot glue gun and glue sticks

Fold napkin into triangle (see Diagram A). Place empty bottle in one corner and wrap napkin around bottle (see Diagram B). Tuck opposite corner under bottom of napkin to secure and fold top point of napkin down (see Diagram C). Glue fruit and leaves to pin back; pin to napkin front. Fill bottle with juice. Repeat with remaining bottles and napkins.

Fresh Fruit Fillers

Diagram A

Three 6" x 12" clear glass vases
Kumquats
Lemons
Limes
Aspen branches
Corkscrew willow branches
Hazelnut bush branches

Fill first vase with kumquats and aspen branches, second with lemons and corkscrew branches and third with limes and hazelnut branches.

Diagram B

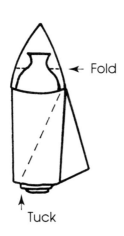

← Fold

Tuck

Diagram C

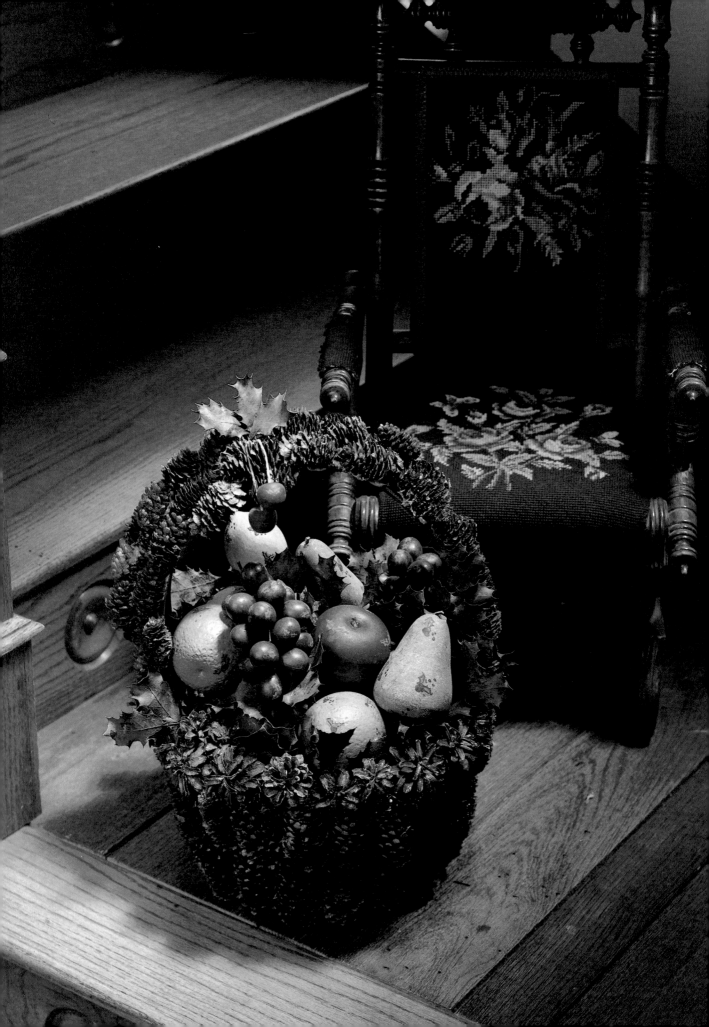

Woodland Bounty

12" oval basket

Assorted wood fruits

60 small spruce cones

30 medium spruce cones

Twenty large spruce cones

30 small ponderosa pinecones

Five large ponderosa pinecones

Acrylic paints: red, green, yellow, orange,
 purple and brown

Sponges

Paintbrushes

Newspaper

Hot glue gun and glue sticks

1. Sponge paint wood fruits in coordinating
colors. Allow to dry. Add holly accents with
paintbrush; see photo. Set aside.

2. Glue large spruce cones closely together
around bottom of basket. Glue medium
spruce cones for second row.

3. Glue small ponderosa pinecones across
top and on inside edge of basket handle; see
photo. Glue spruce cones on outside of
handle, using larger cones first then filling in
spaces with smaller ones.

4. Crumple newspaper and tightly pack into
bottom of basket to within 2" of rim.
Arrange fruit and remaining large ponderosa
pinecones in basket as desired.

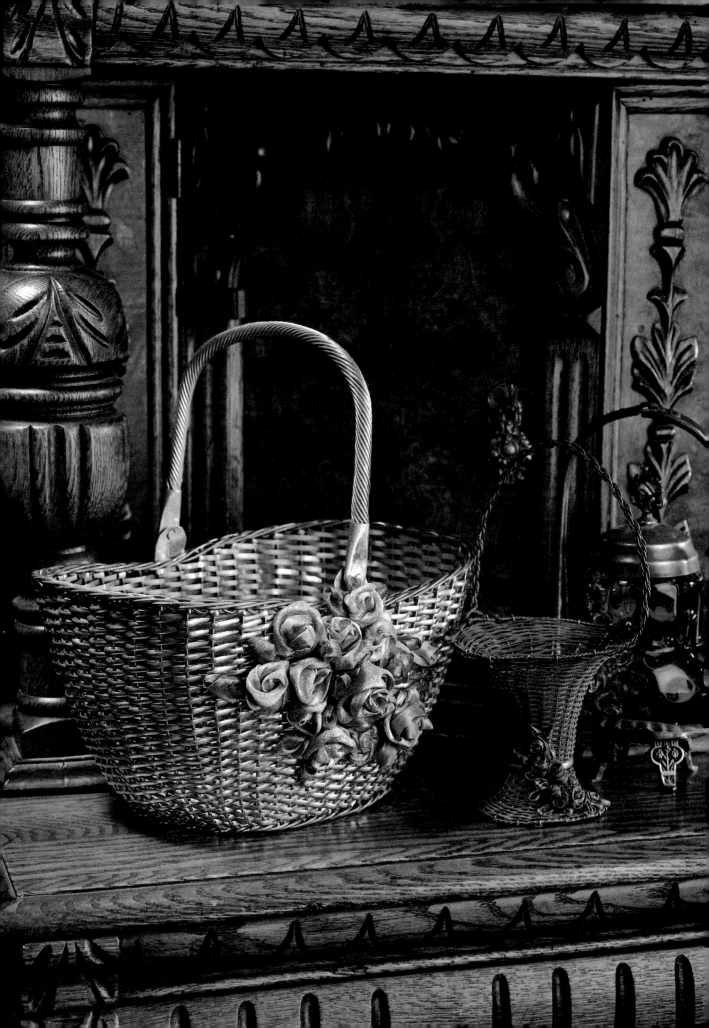

Metal Petals

8" x 11" silver and gold oval wire basket
Small bronze flower stand wire basket
2¼ yards of 2" gold mesh wired ribbon; matching thread
1½ yards of 2" silver mesh wired ribbon; matching thread
Watercolor paints: bronze and silver
Paintbrushes
Needle and thread
Bronze spray paint
Hot glue gun and glue sticks

1. To make ribbon roses, cut three 5" lengths of gold ribbon. Also cut nine 5" lengths and three 3" lengths of silver ribbon; see General Instructions on page 158.

2. To make leaves, cut gold ribbon into ten 3" lengths then cut in half horizonally; see General Instructions on page 158.

3. Paint roses and leaves with corresponding water color. Allow to dry. Glue flowers to silver and gold basket; see photo.

4. To make flowers on bronze basket, cut gold ribbon into ten 3" lengths, then cut lengths in half horizontally. See General Instructions for roses, rosebuds and leaves. Spray with bronze paint and glue to basket; see photo.

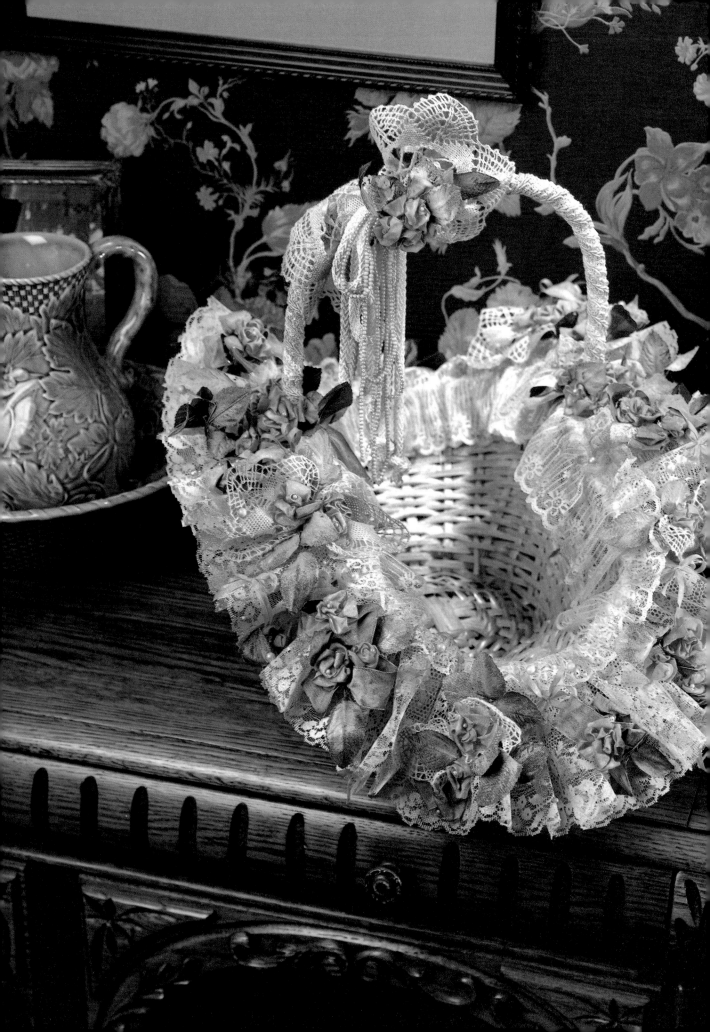

Frilly Floral Basket

19" white bridal basket
4 yards of 4½" white flat lace
3 yards of 3½" white flat lace
100 silk rose leaves
24 yards of ¾" peach wired ribbon
1½ yards of 1" gold-trimmed green wired
 ribbon
4 yards of ⅛" peach satin ribbon
1 yard of ¼" pink organdy ribbon
Four small cream crocheted doilies
Two medium cream crocheted doilies
Large cream crocheted doily
1 yard of ½" white braid
1 yard of ½" peach braid
1½ yards of ⅝" white rope
1½ yards of strung peach beads
60 assorted sizes of loose peach beads
Gold acrylic paint
Sponges
Needle and thread
Fabric stiffener
String
Gold spray paint or glitter
Hot glue gun and glue sticks

1. Sponge paint leaves gold. Allow to dry.

2. Cut peach wired ribbon into 2" lengths.
Fold four to twelve 2" lengths each in half
with short raw edges aligned. Line up folded
lengths side by side with fold at top. Stitch
together ¼" from raw edges (see Diagram
A). Roll ribbon into rose shape. Stitch and
glue ends to secure (see Diagram B). Glue
peach bead to top of center ribbon petal.
Repeat to make 45 roses. Set aside.

3. Cut green wired ribbon into 10 equal
lengths. To make ribbon leaves, fold one
ribbon length in half with short edges
aligned. Twist raw edges together; glue to
secure. Shape ribbon as desired. Set aside.

4. Cut peach satin ribbon into thirty 5"
lengths. Handling two lengths as one, tie
bow. Repeat with remaining lengths to make
15 bows. Cut pink organdy ribbon into 10
equal lengths. Tie one length into a bow.
Repeat with remaining lengths to make 10
bows. Set aside.

5. Tie string around middle of small doily.
Repeat with remaining doilies. Set aside.

6. Sew gathering threads along one edge of
4½" lace and gather to fit outside edge of
basket top; glue into place. Apply fabric
stiffener. Allow to dry.

7. Sew gathering threads 1" in from one
edge of 3½" lace. Gather to fit around inside
edge of basket top. Glue lace to basket with
stitching line covering inside edge of 4½"
lace. Wide edge of 3½" lace should fall
toward inside of basket.

8. Wrap and glue white braid around basket
handle. Repeat with peach braid; see photo.

9. Glue large doily to top of handle. Tie rope
and string beads into two bows; glue on top
of doily middle. Glue leaves, ribbon leaves
and roses on top of braid and beads; see
photo.

10. Glue clusters of doilies, leaves, ribbon
leaves and roses around basket on lace and
trim; see photo. Glue peach bows, pink
bows and loose beads on lace.

11. Spray gold paint or glitter over basket.

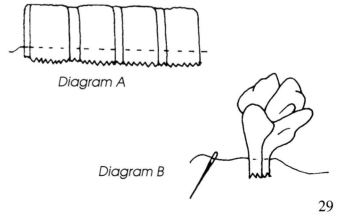

Diagram A

Diagram B

29

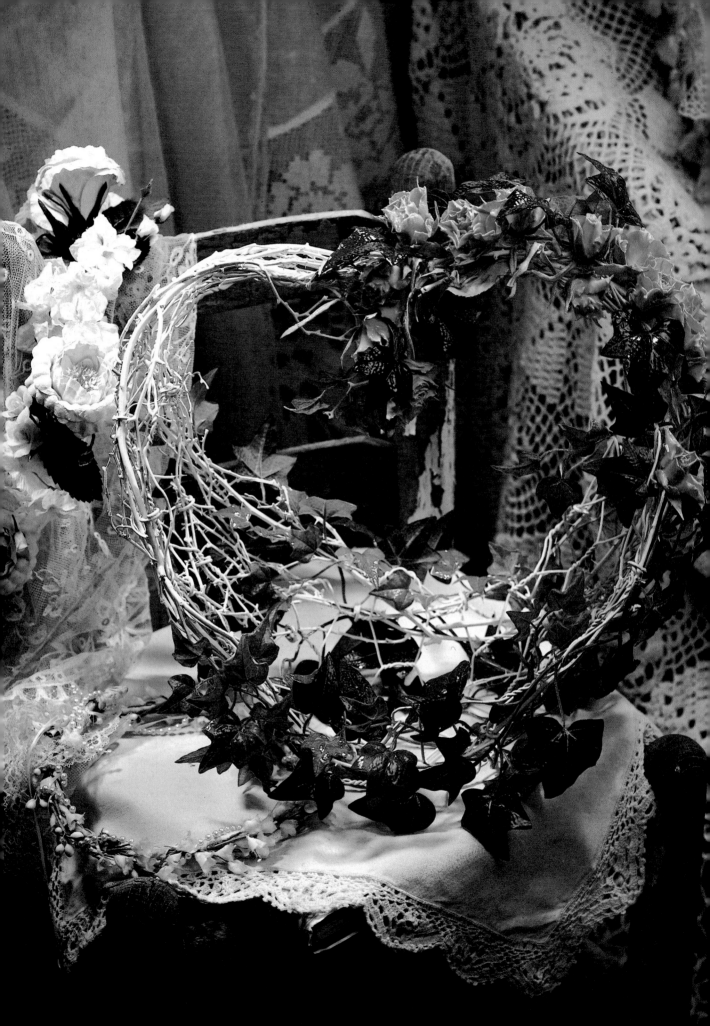

Dainty Ivy and Roses

10" x 46" piece of chicken wire

Large and small climbing rose stems

Silk ivy

Eighteen dried pink roses

White spray paint

Mediumweight craft wire

Clear resin spray glaze

Garden gloves

Hot glue gun and glue sticks

1. Spray paint chicken wire and rose stems white. Allow to dry.

2. Protecting hands with gloves, weave rose stems through chicken wire. Form wire into heart-shaped basket by bunching ends together and securing with craft wire at top; see photo. Stretch out bottom into stable base.

3. Weave ivy through basket. Glue roses to basket; see photo. Spray resin over ivy and roses. Allow to dry.

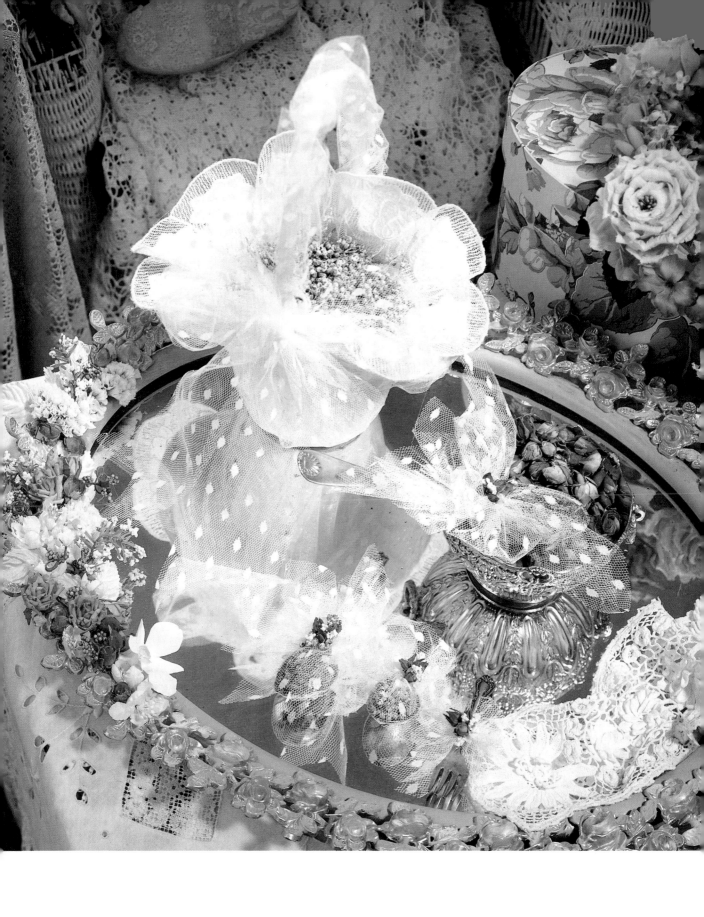

Bridal Basket Bouquet

Page 33

3" x 12" white bridal basket
¼" yard of 45" white bridal netting
4 yards of 3" fine dotted netting
1 yard of 4" netted satin lace
Dried lavender
Dried white rattan palm
Potpourri
Hot glue gun and glue sticks

1. Position basket in middle of white netting. Pull netting up and around basket. Glue raw edges to inside of basket.

2. Wrap dotted netting around handle. Tie a double bow at bottom of handle. Cut V shapes from end of netting tails; see photo.

3. With right sides facing, stitch short raw ends of satin lace together. Gather and glue straight edge of satin lace around inside rim of basket, allowing decorative edges to rest around rim. Fill inside of basket with lavender, rattan palm and potpourri.

Sachet Silverware

Page 33

Silver baby spoon and fork
Silver tablespoon and serving spoon
Potpourri
White bridal netting
Florist's wire
Dried baby red rosebuds
Dried miniature white berries
Hot glue gun and glue sticks

Fill spoons with potpourri and cover with white netting. Wrap florist's wire around base of spoon to secure netting. Make bows with netting; glue to spoons and fork. Glue baby rosebuds and white berries to center of bows; see photo.

Romantic Reflections

Page 33

19½" x 22½" framed mirror
Dried pink roses
Dried white orchid
Dried baby red rosebuds
Silk white statice
Silk green and white berries
White paper flowers
Hot glue gun and glue sticks

Glue flowers and berries to mirror frame; see photo.

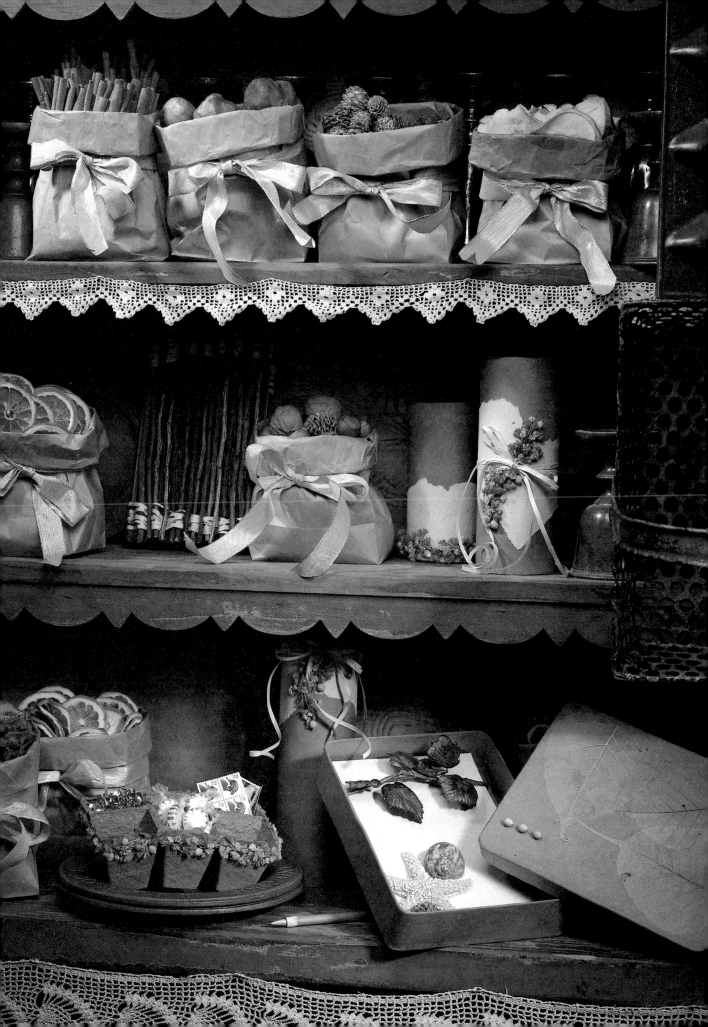

Dapper Desk Caddy

Page 35

Six 2¼"-square cardboard planting pots
3" x 31½" cardboard mailing tube
Dried pink statice
Dried yellow happy flowers
Dried white rattan palm
White construction paper
6 yards white raffia
7" x 2" purchased brown paper box
Three purchased skeleton leaves
Seashell
Small pinecone
Starfish
No. 2 pencil
No. 5 paper bag
Silk ivy
Stationery
Orange acrylic paint
Sponge
Spray adhesive
Hot glue gun and glue sticks

1. Cut mailing tube into 9" length, 7½" length and 6" length.

2. To make large desk supplies organizer, tear construction paper into three lengths and glue to tubes as desired. Decorate each tube with dried statice, flowers and rattan palm; see photo. Tie raffia bows around tubes; curl end of raffia by twisting around end of pencil.

3. To make small desk supplies organizer, glue 16" piece of raffia around outside of planting pots. Glue statice, flowers and rattan palm to pots as desired.

4. To decorate stationery box, attach three skeleton leaves and rattan palm to lid with spray adhesive. Sponge paint ivy leaves with

orange paint. Allow to dry. Wrap ivy around stationery and place in box. Set seashell, starfish and pinecone on top of stationery.

5. To decorate pencil, cut paper bag to fit around pencil; glue. Using scraps of construction paper, glue small piece to pencil top and bottom.

Twigged Tome

Page 35

5" x 8½" dark green journal
Thirty ⅛" x 8½" twigs
Acrylic paints: gold, copper, brown, light
 green and dark green
12 strands of 16" raffia
Paintbrushes
Crazy glue

1. Paint five twigs in each of five colors, leaving five unpainted. Allow to dry.

2. Glue ends of six raffia strands together and glue first 3" to inside of book cover about 1½" from top edge. Repeat with remaining strands, gluing to inside of book cover 1½" from bottom edge. Weave raffia under and over twigs, gluing raffia and twigs to book; see photo. Continue weaving and gluing onto back cover. Glue ends of raffia strands to inside of back cover.

Brown Bag Scents

Page 35

No. 5 brown paper bag
½ yard of ⅝" gold metallic ribbon

Filler Options:
Eight sliced kiwi, dried
Eight sliced limes, dried
Eight sliced lemons, dried
Four sliced oranges, dried
Four sliced apples, dried
Fifteen dried pomegranates
80 cinnamon sticks
Mixed nuts in shell

1. Slice kiwi, limes, lemons, oranges and apples. Place on cookie sheets. Dry overnight in warm oven.

2. Double fold top of bag 1". Tie ribbon in bow around bag under fold, gathering bag somewhat; see photo. Fill bag with dried fruits, cinnamon sticks or nuts.

May Flowers Basket

Page 38

14" oval basket
Dried lemon leaf sprigs
Dried lavender lilacs
Dried white lilacs
Dried lavender
Six dried red peonies
Two dried white peonies
Hot glue gun and glue sticks

Glue leaves, lilacs, lavender and peonies to basket; see photo.

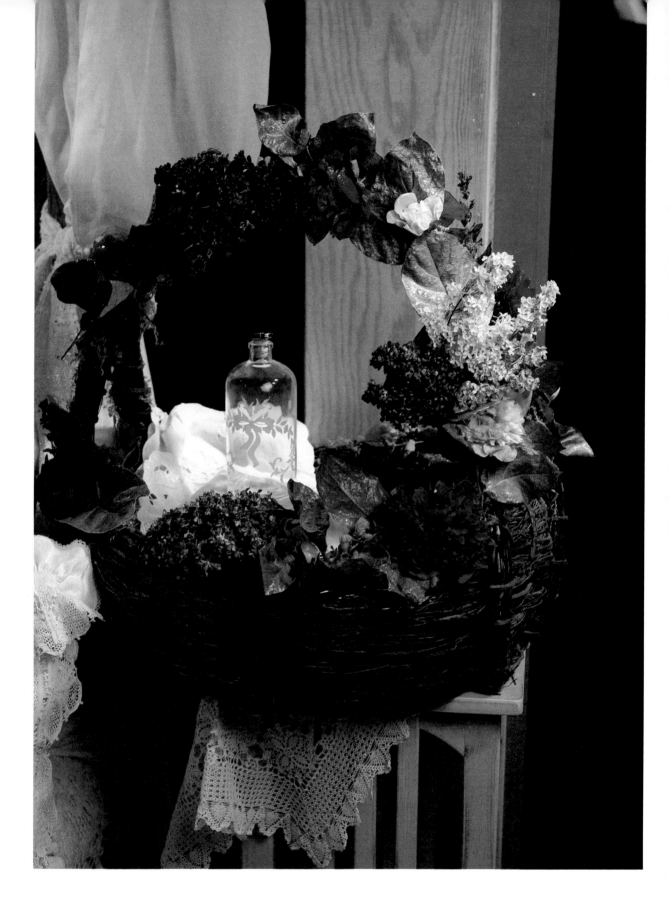

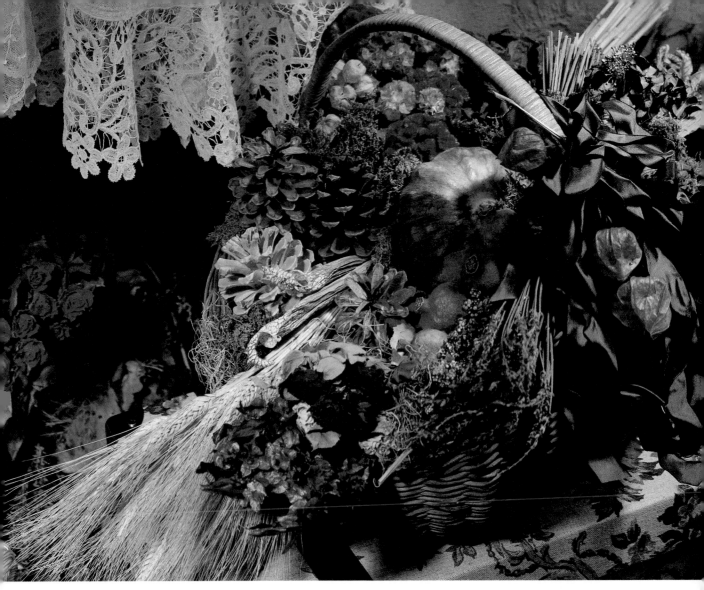

Autumn Delight

9" flower basket

Sheet moss

Dried long-stemmed wheat

Dried lavender

Dried red docket

Dried eucalyptus

Dried red roses

Dried pomegranates

Pinecones

Dried artichoke

Dried red phlox

Dried rattan palm

Dried orange lanterns

8 yards of ⅝" green wired ribbon

Florist's wire

Hot glue gun and glue sticks

1. Glue moss to bottom of basket. Glue wheat, lavender, red docket, eucalyptus and roses at base. Glue pomegranates, pinecones, artichoke, red phlox and rattan palm on top.

2. Make fourteen 4" loops with wired ribbon and secure together with florist's wire. Glue bow to basket handle. Decorate ribbon with lanterns and flowers as desired.

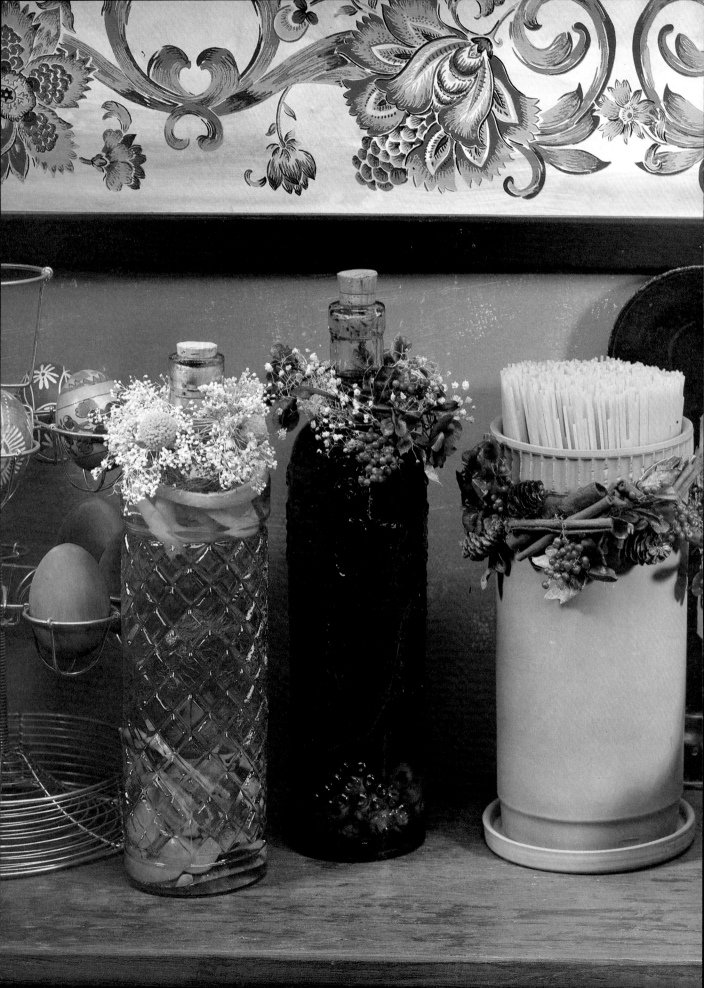

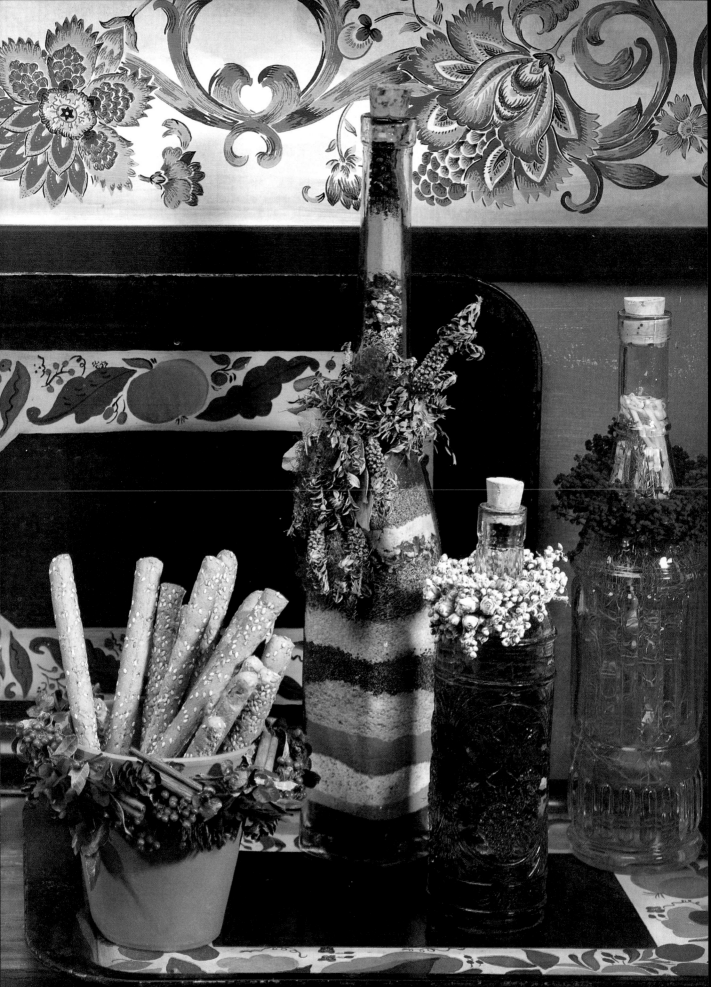

Vintage Vinegars

Two 13" corked glass wine bottles
12" corked glass wine bottle
9½" corked glass wine bottle
Gallon white distilled vinegar
Fresh raspberries
Fresh thyme
Fresh enoki mushrooms
Fresh fennel
Fresh tarragon
Lemons
Limes
Mangos
Dried red dudinea
Baby's breath
Dried purple statice sinuata
Dried yellow craspedia
Dried yellow happy flowers
Dried baby yellow rosebuds
White seed pods
Hot glue gun and glue sticks

1. Fill about 1" of bottom of 13" bottle with raspberries, then with thyme as desired. Fill bottle with vinegar. Fill second 13" bottle with enoki mushrooms as desired. Fill with vinegar. Slice lemons, limes and mangos. Place slices in 12" bottle. Add fennel. Fill with vinegar. Place tarragon in 9½" bottle and fill with vinegar.

2. Make small wreaths with flowers by gluing stems together, extending and rounding them into a circle. Measure around necks of bottles and make wreath openings to fit.

3. Glue and shape red dudinea and baby's breath into wreath. Place around neck of first bottle. Glue purple statice sinuata into wreath. Place around neck of second bottle. Glue baby's breath, yellow craspedia and happy flowers into wreath. Place around neck of third bottle. Glue yellow rosebuds and white seed pods into wreath. Place around neck of last bottle; see photo.

Fancy Clay Jars

5" x 9½" clay wine cooler
4½" x 5" clay pot
Miniature pinecones
Dried pepper berries
Dried leaves
Dried red dudinea
Cinnamon sticks
Breadsticks
Spaghetti
Hot glue gun and glue sticks

Glue pinecones, pepper berries, leaves, dudinea and cinnamon sticks around rim of pot and wine cooler; see photo. Fill with breadsticks and spaghetti.

Spice Landscape

17½" corked glass bottle
Chili powder
Turmeric
Garlic salt with parsley
Cinnamon
Bran flour
Poppy seeds
Sesame seeds
Basil
Garlic powder
Celery seeds
Parsley
Red pepper
Peppercorns
Dried red bottle brush
Hot glue gun and glue sticks

1. Fill about 1" of bottom of bottle with chili powder. Continue to fill bottle with spices, flour and herbs as listed above; see photo.

2. Make a small wreath with red bottle brush by gluing stems together, extending and rounding them into a circle. Measure around neck of bottle and make wreath opening to fit. Place wreath around neck.

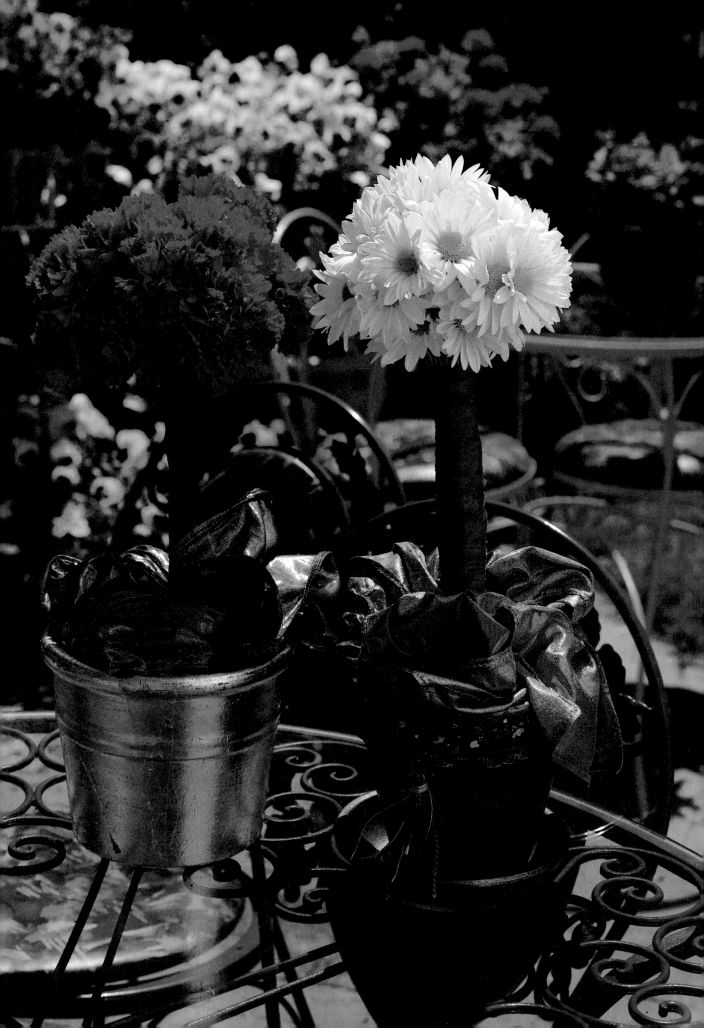

Meadow Topiaries

7" x 6½" clay pot

6" x 5½" clay pot

Gold leaf sheets

Orchid bark

Ten fresh yellow daisies

Fourteen fresh red carnations

6 yards ½" red organdy ribbon

6 yards ½" green organdy ribbon

Neck scarves: green and brown

½ yard ¾" multicolored braid;
 matching tassle

Two metal florist's frogs

Two juice glasses

Acrylic paints: green, gold, white, red
 and purple

Paintbrushes

Hot glue gun and glue sticks

1. Peel gold leaf sheet. Place on 7" pot. Brush on with a stiff paintbrush; burnish.

2. Paint 6" clay pot green. Allow to dry. Sponge paint small amounts of gold over green. Allow to dry. Trace pattern and transfer around rim. Repeat to cover rim. Paint as desired. Tie and glue braid around pot; glue tassle in front.

3. Place metal florist's frogs into juice glasses. Fill with water. Place in pots. Wrap flower stems with 6 yards each of organdy ribbon; tie a knot at bottom to secure. Place in juice glasses. Fill pots with orchid bark. Loop, twist and tuck scarves into top of pots.

Rim Flowers

Something Old, Something New

Familiar flowers used in
novel ways can arouse old
memories and create new
ones. You smell sweet
buttercups and roses, then
remember the tickle of a
breeze on bare feet as a
friend pushed you on a
swing in late spring when
blooms burst fragrant.

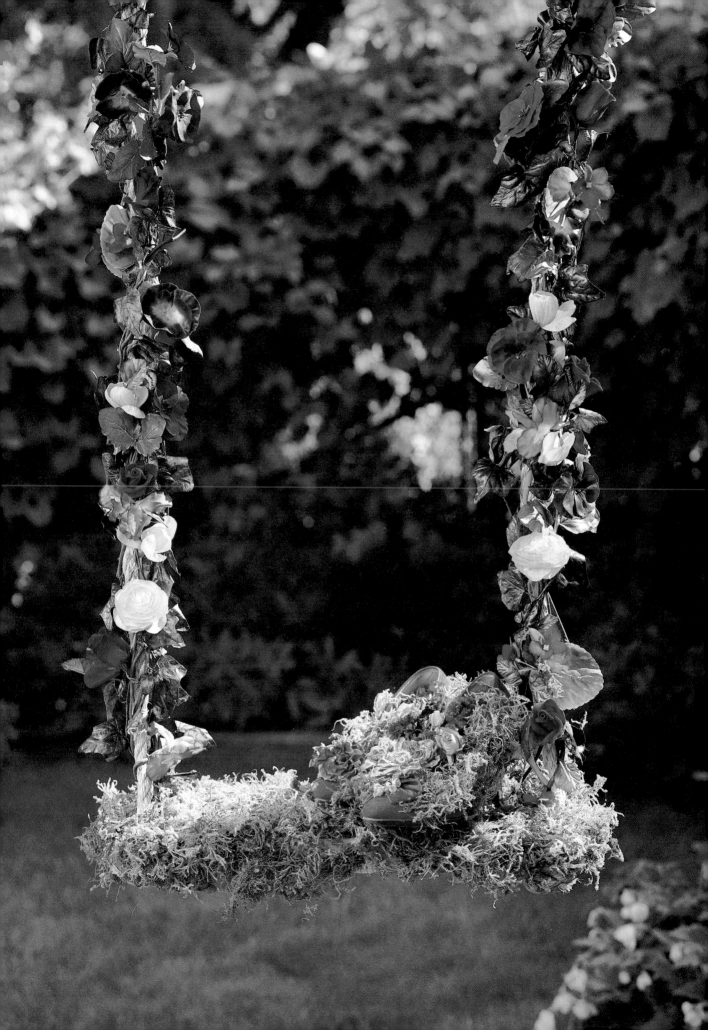

Sweet Spring Swing

Page 47

25 feet ½" jute rope
25 feet No. 12 gauge wire
2" x 6" x 15" pine board
Pair high-heeled shoes
Craft bird nest
Hot glue gun and glue sticks
Silk red roses
Silk purple pansies
Silk yellow ranunculus
Silk lavender iris
Dried red roses and rosebuds
Dried yellow roses
Dried purple statice
Dried miniature purple berries
Ivy
Moss

1. Drill 1"-wide holes 2" from each corner of pine board for swing seat. Cut rope in half. Feed one rope end down hole and back up opposite hole on same side. Wire rope together. Repeat on other side.

2. Wind ivy around rope; glue. Glue silk roses, pansies, ranunculus and iris to rope as desired. Glue moss to seat of swing. In shoes, glue moss, dried roses, rosebuds, statice and berries. Glue shoes and bird nest to swing seat; see photo.

Memories Abloom

8½" x 10" wood picture frame
Sheet moss
Eight dried yellow rosebuds
Dried rattan palm
Dried rose leaves
Dried fern leaves
Dried boxwood leaf sprigs
Hot glue gun and glue sticks

Glue moss to frame. Glue remaining materials on top of moss; see photo.

Mother Nature's Closet

Page 50

Three wood clothes hangers
Sheet moss
Assorted dried roses
Baby's breath
Dried sweet peas
Assorted dried flowers
Hot glue gun and glue sticks

Glue moss to front and back of wood on hangers. Glue roses, baby's breath, sweet peas and flowers to moss on hanger front; see photo.

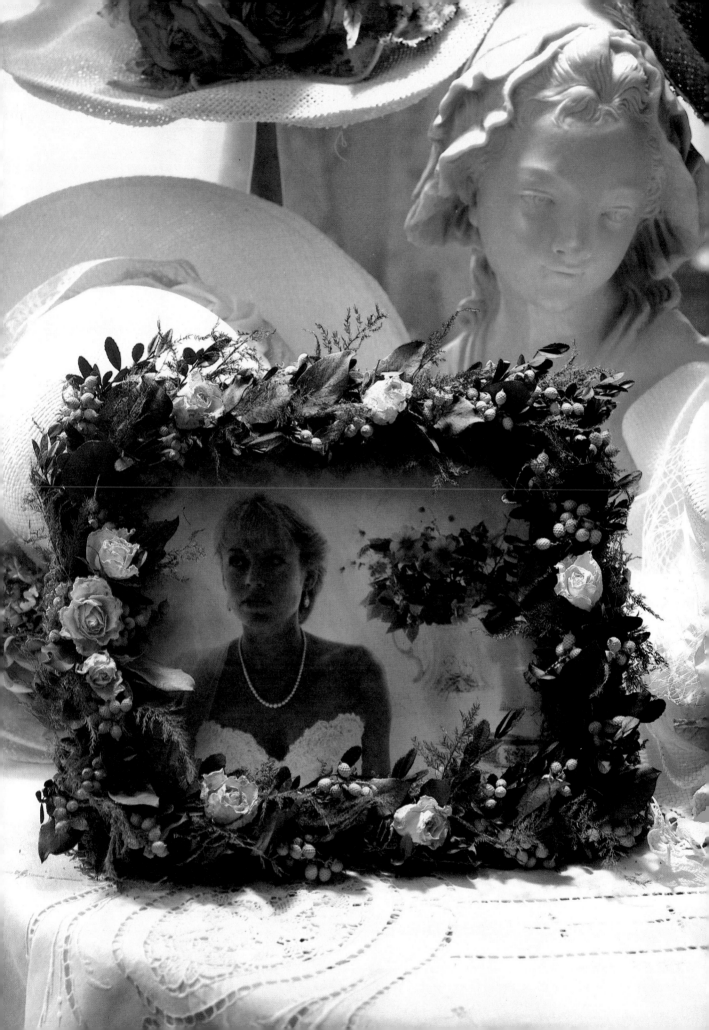

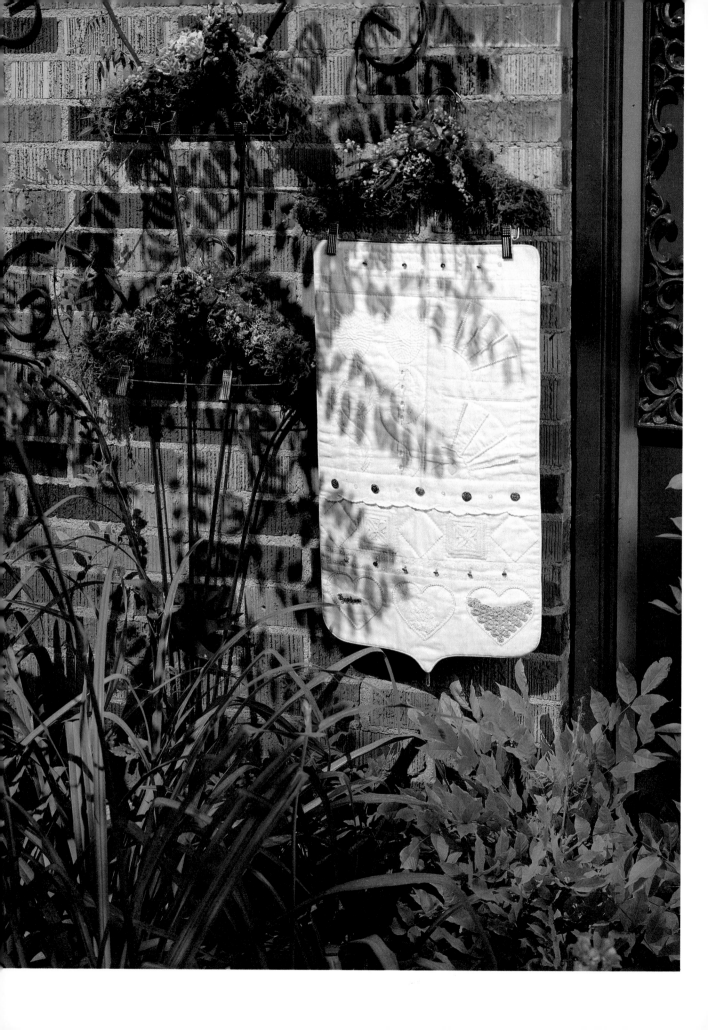

Bright Blooms

Page 51

16" black lamp with cloth-covered shade

Twenty 2" galax leaves

Sheet moss

Dried boxwood leaf sprigs

30 dried small red roses

Baby's breath

Dried pepper berries

Spray adhesive

Hot glue gun and glue sticks

1. Spray one side of galax leaves with adhesive. Attach to lamp base, overlapping; see photo.

2. Glue moss to outside of lamp shade. Glue boxwood leaf sprigs on moss. Glue eight red roses around top of shade over leaf sprigs. Glue remaining roses in two staggering rows along middle and bottom of shade. Glue baby's breath and berries to shade; see photo.

Bed of Roses

13" x 21" purchased willow bed

¼ yard floral print fabric; matching thread

2 yards of 5" cream lace

Polyester stuffing

19" x 11" piece of mediumweight cardboard

Sheet moss

Dried rose leaves

Dried violets

Twenty dried white roses

15" x 34" piece of cream lace

Hot glue gun and glue sticks

1. To make pillows, cut four 5½" circles from floral print fabric. Cut lace into two equal lengths for trim.

2. With right sides facing, stitch lace ends together. Fold lace in half lengthwise with wrong sides facing and sew gathering threads on long raw edges. Gather to fit floral circle, distributing fullness evenly.

3. With right sides facing, sandwich lace between two floral circles. Stitch, leaving a small opening. Turn. Stuff moderately. Slipstitch opening closed. Repeat with remaining lace piece and floral circles.

4. To make bed, place cardboard on bed and glue moss in layers to cardboard as desired. Glue leaves, violets and roses to moss in middle of bed, leaving about 5" of open space at head and foot; see photo.

5. Place pillows at head of bed. Fold 15" x 34" lace piece across foot of bed.

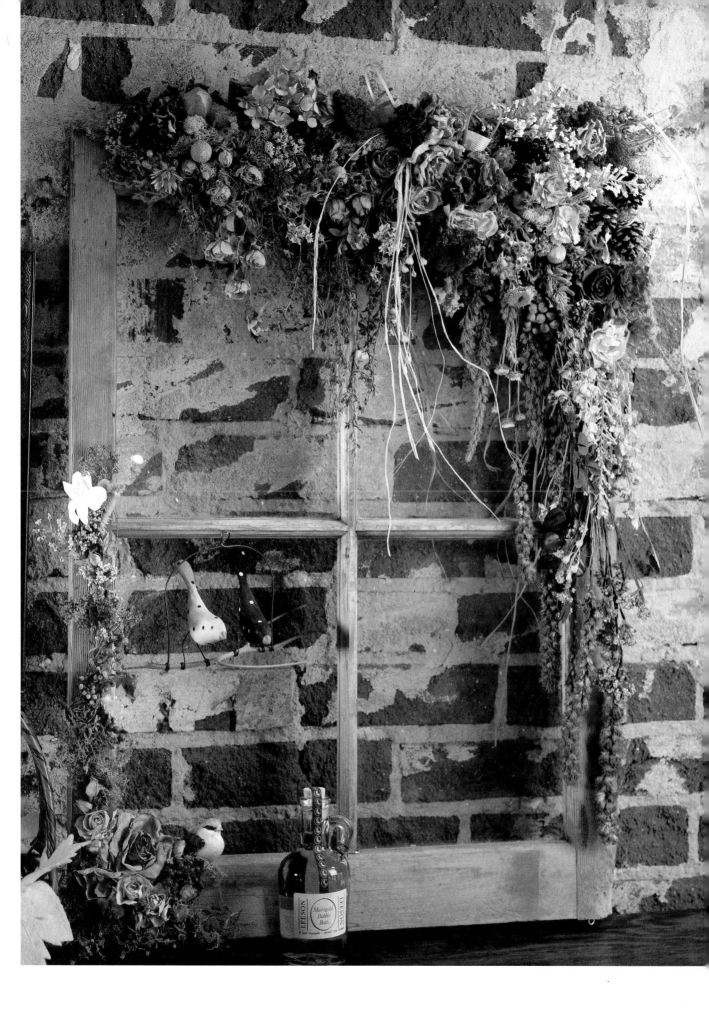

Climbing Garden

Page 54

4' wood stepladder

Sheet moss

Assorted dried flowers

Silk leaves

Plastic and dried berries

Two mushroom birds

3½" x 3" clay pot

Two 2" x 2" clay pots

Two 4½" x 3½" clay pots

4" straw basket

Five live potting plants

Potting soil

2 yards of 1" floral ribbon

Two 8-ounce bottles of dark green dye

Sponge

Clear resin spray

Florist's wire

Hot glue gun and glue sticks

1. Mix one quart water to two 8-ounce bottles of dye. Using a sponge, spread dye over entire laddder. Allow to dry. Spray ladder with clear resin. Allow to dry.

2. Glue moss to ladder; see photo. Glue small dried flowers into basket. Add dried flowers, leaves, berries, birds and basket to moss and ladder as desired.

3. For bow, make four 3½" loops, secure with florist's wire. Glue to ladder; see photo.

4. Pot live plants as desired. Glue clay pots to ladder; see photo.

Creation's View

Page 55

Old window frame without glass

Purchased bird hanger (optional)

Sheet moss

Assorted dried statice

Assorted dried roses

Dried titree

Dried strawflowers

Dried celosia

Dried heather

Pinecones

Dried eucalyptus

Dried rattan palm

Dried pepper berries

Raffia

Small nail

Hot glue gun and glue sticks

1. Glue moss across top and down right side of frame. Glue assorted dried flowers, pinecones, eucalyptus, rattan palm, berries and raffia to moss; see photo.

2. Hammer nail into frame and position bird hanger as desired.

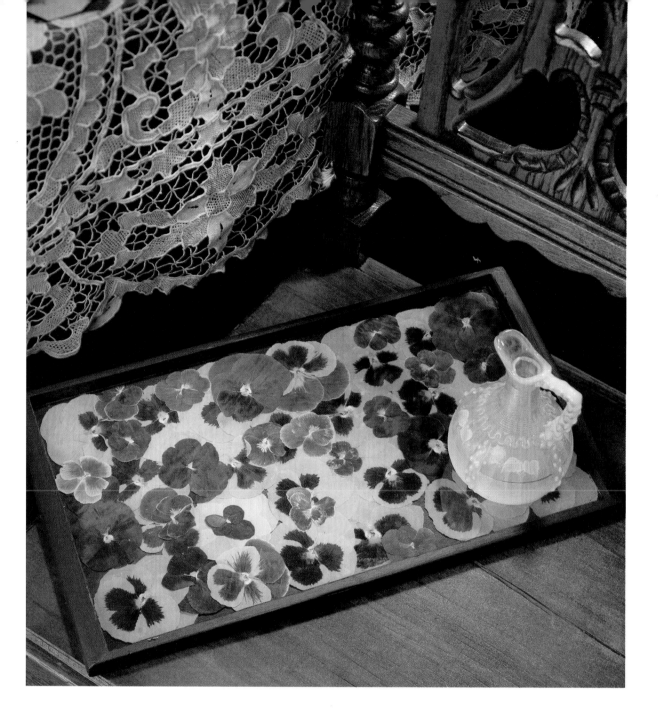

Pretty Pansy Tray

9½" x 16½" glass tray
50 pressed pansies
Purple acrylic paint
Paintbrush
Spray adhesive

Press pansies between pages of a heavy book. Allow one week to dry. Paint tray purple. Allow to dry. Spray adhesive on tray and layer pansies over adhesive to secure. Secure glass over tray.

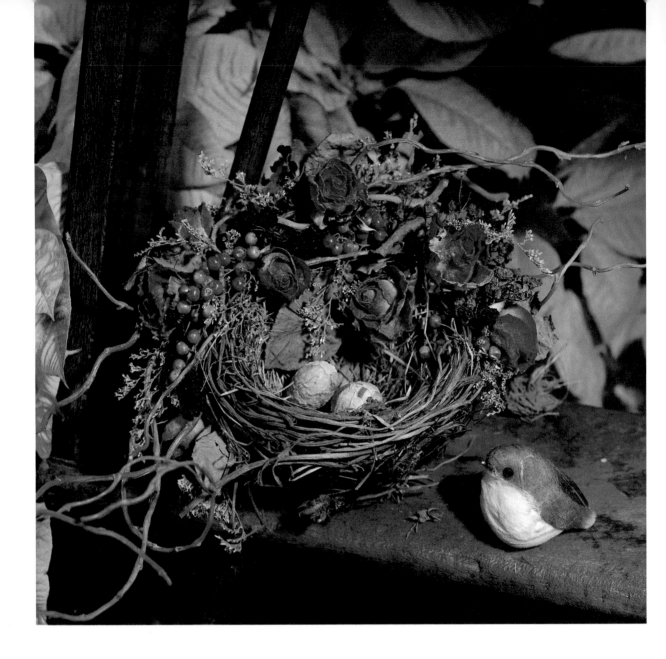

Victorian Dream Nest

4½" craft bird nest

Willow branches

Nine dried red roses and leaves

Dried red and purple berries

Dried German statice

Two wood eggs

Mushroom bird

Hot glue gun and glue sticks

Glue willows and rose leaves to top of nest.
Add remaining materials; see photo. Glue
rose petals to wood eggs. Place eggs in nest.

58

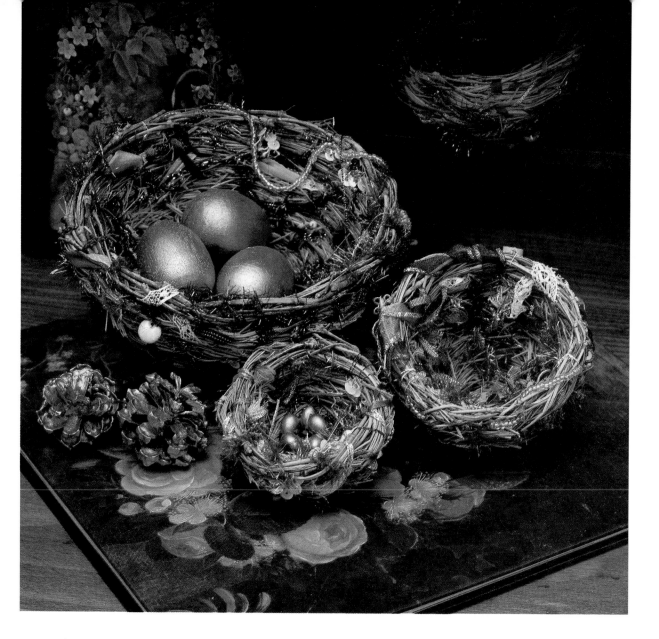

Sticks and String

Three craft bird nests in graduated sizes

Assorted ribbons

Assorted string

Assorted strung beads

2 yards of ¼" lace

Assorted small buttons

Large and small needles

Three large wood eggs

Six small plastic eggs

Gold or copper spray paint

Hot glue gun and glue sticks

Using needles, weave ribbons, string, beads and lace throughout nests; see photo. Buttons can be strung as desired. Spray paint eggs. Allow to dry. Glue to bottom of nests; see photo.

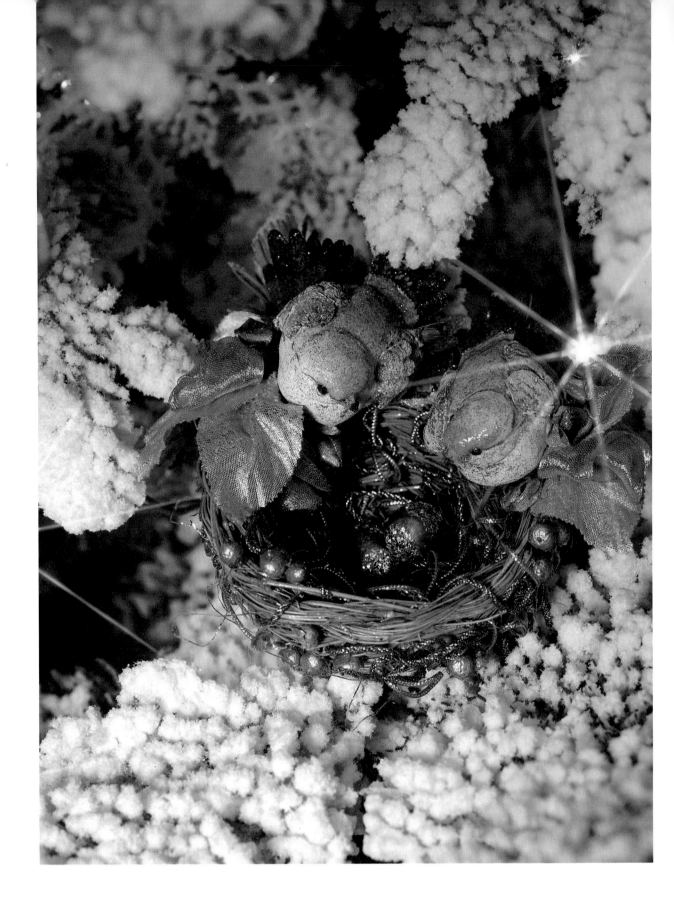

Holiday Glitter

4" craft bird nest
2 yards of ¹⁄₁₆" gold metallic cord
2 yards of ¹⁄₁₆" antique gold cord
Gold blending filament
Two wood eggs
Dried rattan palm
Heavy gold glitter
Six peach cloth leaves
10" of 1½" wired gold sheer ribbon
Two peach/brown mushroom birds
Large and small needles
Gold spray paint
Tacky glue
Gold spray glitter
Hot glue gun and glue sticks

1. Spray paint eggs and rattan palm gold. Roll ends of each egg in tacky glue, then gold glitter. Allow to dry.

2. With large needle, weave gold and antique gold cord around and through nest, twisting and hot gluing as desired. With small needle, weave pieces of blending filament throughout nest. Glue gold rattan palm on outside of nest.

3. Glue four leaves on left edge of nest toward back and two leaves on opposite edge. Cut wired ribbon into two 5" lengths. See General Instructions on page 158 to make two ribbon roses. Glue roses on top of leaves. Glue birds on top of nest; see photo.

4. Spray glitter on leaves, ribbon and birds. Place gold eggs in basket.

Lace-Feathered Nest

Page 62

8" purchased bird nest basket
Spanish moss
Baby's breath
Dried strawflowers: lavender, white
 and pink
Twelve dried pink rosebuds
2 yards of ¼" white silk ribbon
8" length of 3" lace
Rose potpourri
Mushroom bird
Hot glue gun and glue sticks

1. Glue 2" band of Spanish moss around top edge of basket. Glue baby's breath, strawflowers and rosebuds to moss as desired.

2. Cut ribbon into two equal lengths. Tie one bow around base of handle on each side; see photo.

3. Stitch lace ends together. Sew gathering threads on straight edge. Gather and place in middle of basket. Fill center with potpourri and place bird on top.

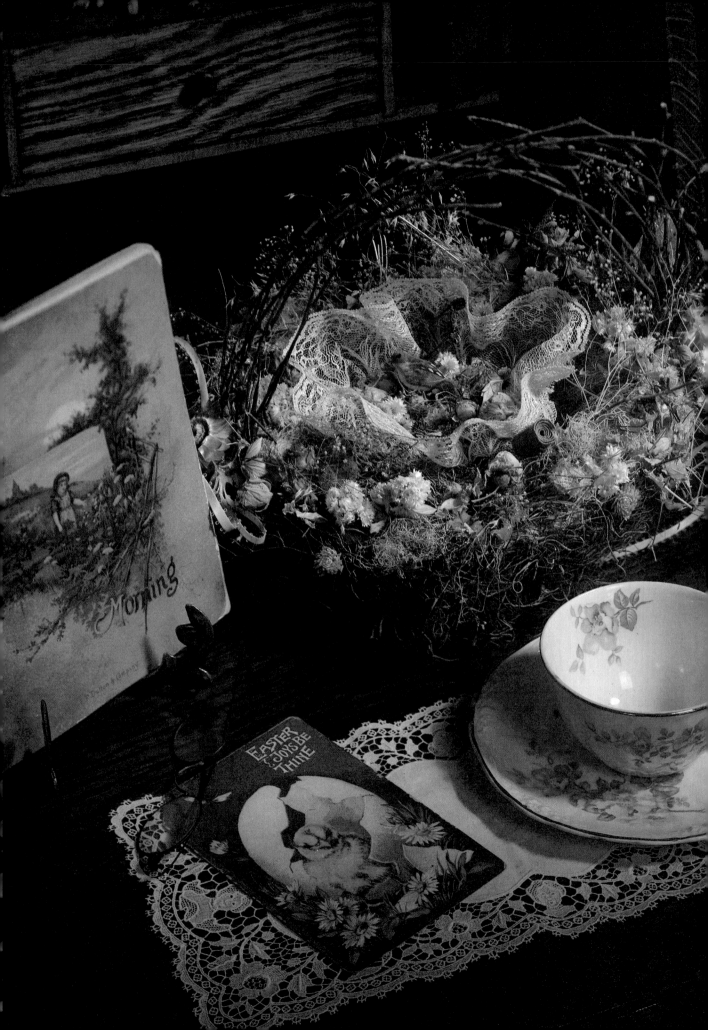

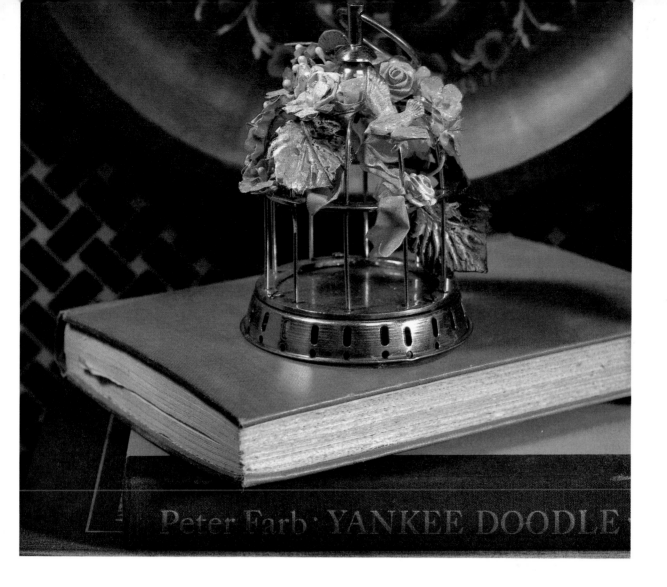

Tiny Aviary

5" bronze bird cage

Silk ivy

Three 1½" white wedding flowers

½ yard of ⅝" melon wired ribbon

Seven ⅝" purchased ribbon roses

Miniature plastic dove

Miniature cloth butterfly

Acrylic paints: gold, copper, antique white,
 purple and pink

Paintbrush

Gold spray glitter

Hot glue gun and glue sticks

1. Paint ivy leaves gold, copper and antique white. Paint wedding flowers purple and pink. Allow to dry.

2. Cut ribbon into two equal lengths and twist throughout top of bird cage, gathering and gluing as desired. Wrap ivy through cage. Glue ribbon roses, flowers, dove and butterfly to ivy; see photo.

3. Spray with gold glitter. Allow to dry.

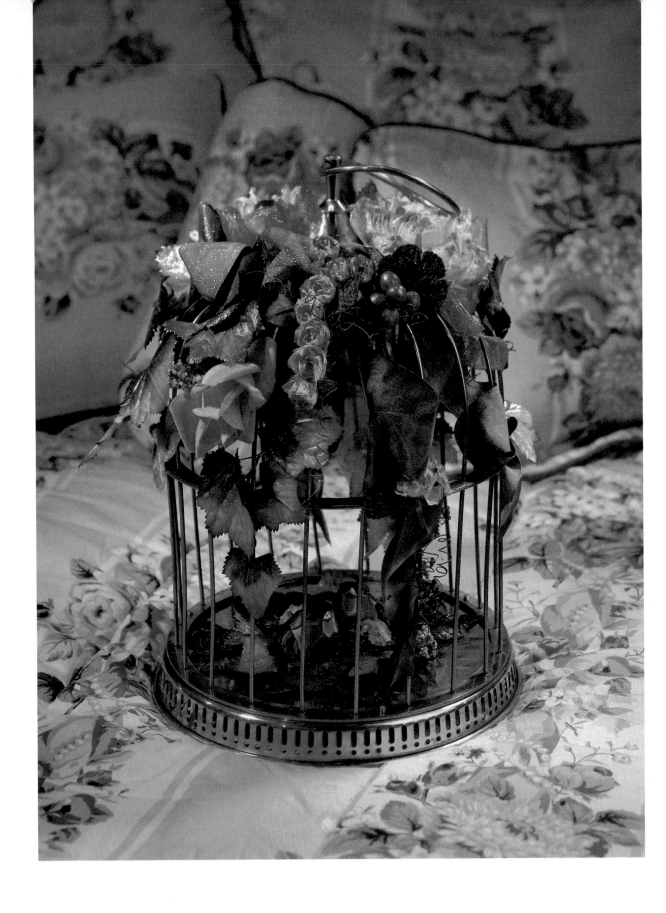

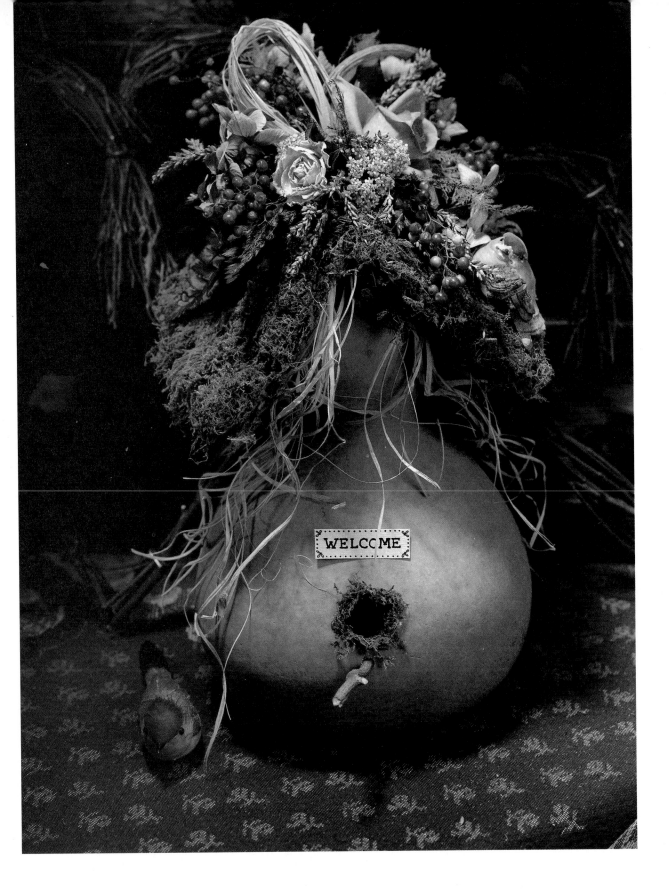

Blooming Loft

Page 64

12" brass bird cage
Silk grape leaves
Sheet moss
Velvet geranium leaves
Two mushroom birds
8 yards of green wired ribbon
Assorted miniature berries
Small silk cabbage roses
Dried pink roses
Gold metallic paint
Sponge
Gold spray glitter
Hot glue gun and glue sticks

1. Sponge paint grape leaves gold. Allow to dry. Glue moss, velvet leaves, grape leaves, berries and birds to bottom inside of cage.

2. Weave wired ribbon through cage, twisting and gluing as desired. Glue additional leaves, berries and roses to top of cage and down sides; see photo.

3. Spray gold glitter over all. Allow to dry.

Welcome Home

Page 65

11" x 8" dried gourd
35" lengths of raffia
12" x 6" piece of mediumweight cardboard
Sheet moss
Dried sanfordi
Dried blue hydrangea
Dried lavender
Dried pepper berries
Dried leather fern leaves
Dried plumosa fern leaves
Dried pink rose
Two small dried yellow roses
Manila folder
Black permanent fine-tip marker
2" length of ¼" willow stick
Hot glue gun and glue sticks

1. Measure and mark center front of gourd 2" from bottom. Drill ¼"-diameter hole at mark. Drill another hole 1" above the first. Widen the second hole to 1" in diameter, using a knife. Empty gourd of seeds through hole.

2. Using about ten 35" lengths of raffia as one piece, tie to gourd stem base, leaving a 6" loop at top and allowing ends to fall freely over front of gourd. Glue raffia knot to stem.

3. Cut mediumweight cardboard into two equal pieces. Glue moss to cover cardboard pieces. Glue pieces to top of gourd for roof, allowing raffia loop and gourd stem to come through and between two roof pieces.

4. Glue leaves, berries and flowers to rooftop, placing pink and yellow roses in front; see photo.

5. Glue small amount of moss around inside edge of large hole in gourd. Glue one end of willow stick into small hole for roost. With marker, write WELCOME on small piece of manila folder; cut out. Glue to gourd front.

Plenty of Personality

Purple Hat
Purple broad-brimmed straw hat
Large safety pin
4" purchased gold fabric rosette
Silk burgundy rose
Hot glue gun and glue sticks

On one side of hat, fold back brim and pin on outside with large safety pin. Glue rosette over pin. Glue rose in center of rosette; see photo.

Cream Bowler
Cream bowler hat
Three dried cream rosebuds
½ yard of 45" cream taffeta
¾ yard small white strung beads
Two large safety pins
Thread to match taffeta
Dental floss
Needle and thread
Hot glue gun and glue sticks

1. Pin brim up from inside with two safety pins spaced 2" apart.

2. Fold taffeta in half lengthwise. With right sides facing, stitch long raw edges. Turn. Fold ¼" seam allowance under on one short end. Insert raw edge and slipstitch closed.

3. Using dental floss and a long stitch, sew gathering threads along seam. Gather to measure 10". Twist taffeta into three flower shapes and secure to hat with glue; see photo.

4. Cut strung beads into three equal lengths; secure ends. Tack one end of one length into middle of one taffeta flower shape. Loop three times and secure loops to taffeta at one point with thread. Glue rosebud at top of bead loops. Repeat with remaining strung beads and rosebuds; see photo.

Cream Straw Hat
Cream broad-brimmed straw hat
Large safety pin
Three yards of 2" purple wired ribbon
Dried lilacs
Dried snowberries
Dried leaf sprigs
Hot glue gun and glue sticks

Pin brim up at one side with safety pin. Tie ribbon in bow around hat crown; glue. Twist and glue ribbon ends to underside of pinned-up brim; see photo. Glue leaves, berries and lilacs to hat as desired.

Khaki Hat
Khaki broad-brimmed straw hat
½ yard of 8" burgundy tulle
Three stems silk lemon leaves
Dried lilacs
Florist's wire
Hot glue gun and glue sticks

Fold tulle in half lengthwise and tie around hat. Spot glue to secure. Glue at knot and let ends hang free. Glue lemon leaves to tulle; see photo. Divide silk flowers into groups of three; wire together securely. Glue flowers over leaves.

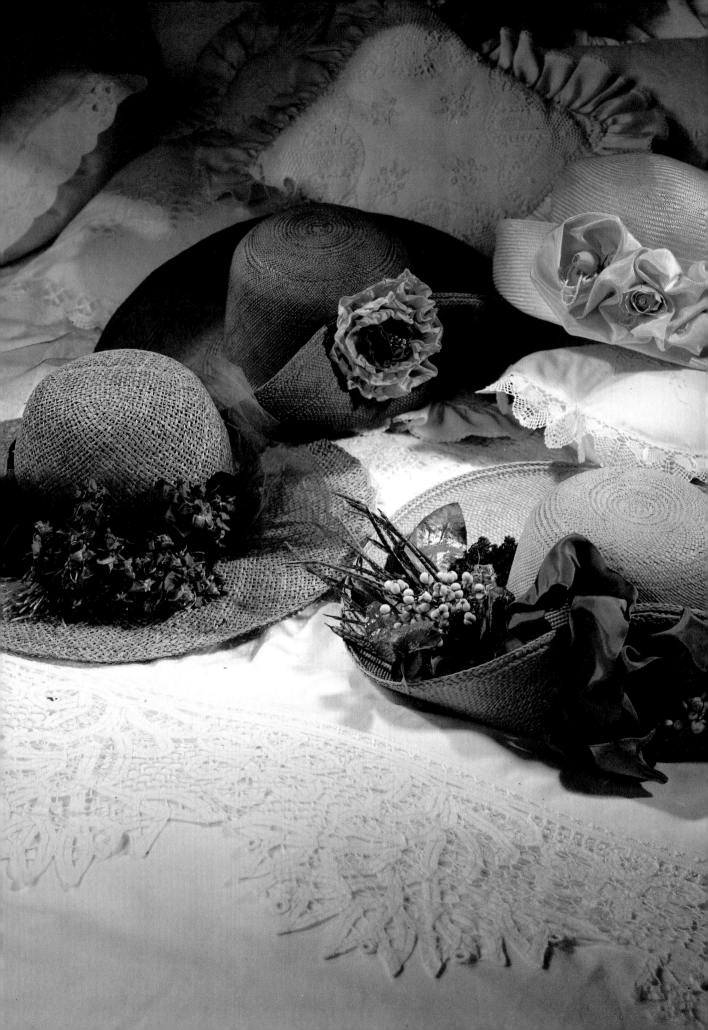

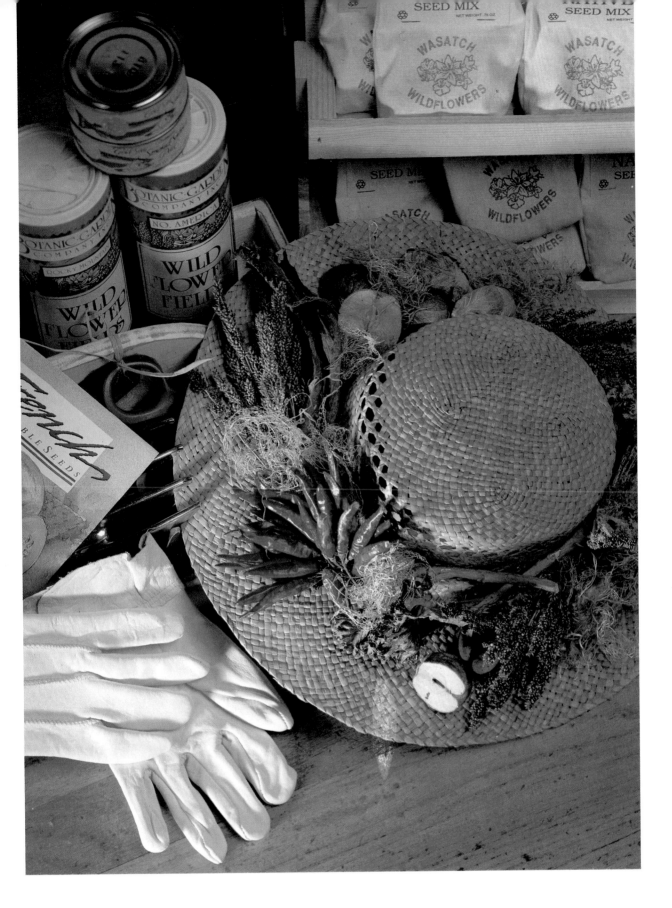

Incredible "Edible" Hat

Page 69

Broad-brimmed straw hat

Eighteen dried lavender sprigs

Bunch dried red chili peppers

Five dried or silk horseradish stalks

Three dried or silk broccoli stalks

Four dried apple halves

Three dried or silk brussels sprouts

Three ounces excelsior

Florist's wire

Hot glue gun and glue sticks

Visually divide hat brim into thirds. Glue one third of lavender at each third of brim. Wire red peppers together at stems; glue between lavender. Glue horseradish, broccoli, apples, brussels sprouts and excelsior to hat; see photo.

Fashionable Hat Stand

Fourteen 30" corkscrew willow branches

Raffia

Four dried roses

Dried pepper berries

Assorted dried flowers

Florist's wire

Hot glue gun and glue sticks

1. Crisscross branches together, leaving 8" legs. Wrap branches tightly with florist's wire; glue together. Allow to dry. Tighten wire.

2. Wrap raffia around center to cover florist's wire. Glue roses, berries and flowers to raffia; see photo.

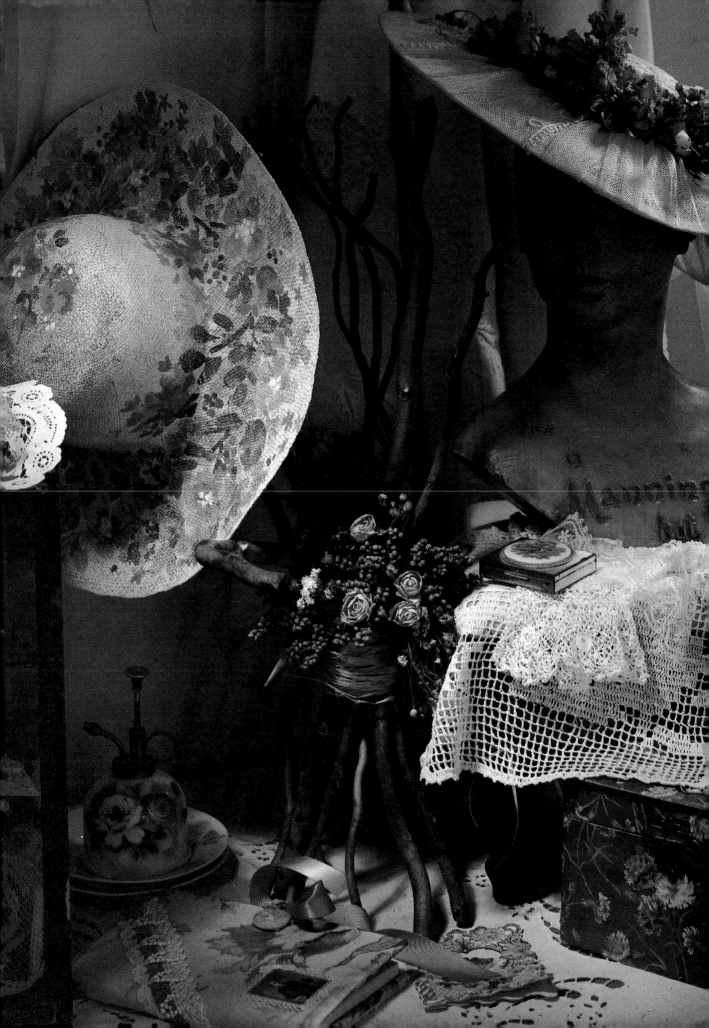

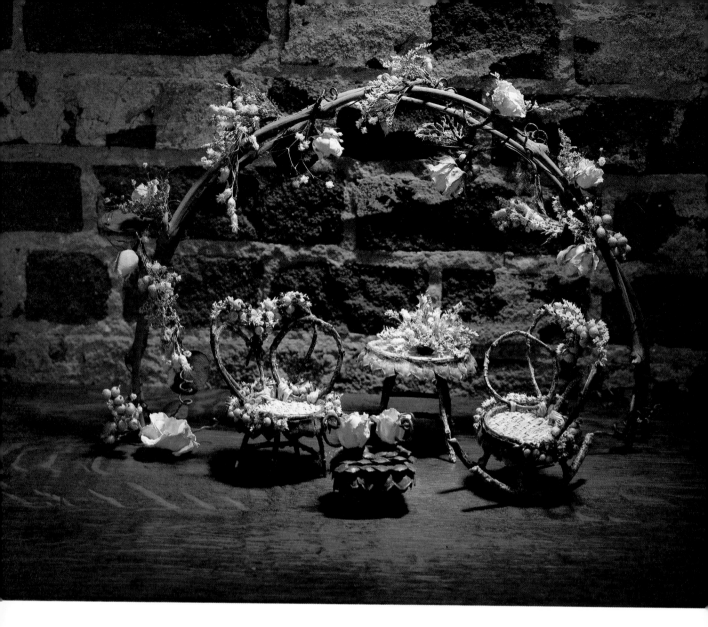

Fairy Palace

Three 31" lengths of grapevine
Dried white statice
Dried caspia
Dried rattan palm
Small dried purple berries
Baby's breath
Dried large eucalyptus leaves
Seven dried white roses
Two dried white rosebuds

Raffia
Small twigs
Pinecones
Florist's wire
String
Florist's tape
Hot glue gun and glue sticks

1. Soak grapevine lengths in water until pliable. Secure three lengths together with florist's wire. Tie string from one end to another to secure arch. Allow to dry. Remove string.

2. Wire together about seven small flower clusters, each containing statice, caspia, rattan palm, berries, baby's breath, a eucalyptus leaf and a rose. Wrap with florist's tape. Wire and glue each cluster to arch as desired.

3. To make chair and rocking chair seats and table top, cut raffia into thirty 3½" lengths for each. Weave fifteen horizontal lengths through fifteen vertical lengths to make 3½" squares. Cut 3"-diameter circle from each square.

4. Soak twigs in water until pliable. For chair, cut two 7½" pieces, three 10" pieces and twelve 2" pieces. For rocking chair, cut two 7½" pieces, three 10" pieces, twelve 2" pieces and two 5½" pieces. For table, cut one 10" piece, eight 2" pieces and four 3" pieces. For stool, cut 24 twigs 1½" long.

5. To make chair, glue 10" piece of twig around outside edge of raffia seat with ends meeting in back. Wrap raffia strands over ends and through raffia seat to secure. Make circles from remaining 10" pieces; secure ends with wire. Set aside. Make heart shape with two 7½" pieces; secure top and bottom ends with wire. Position heart at back of seat; see photo. Glue in place. Wrap raffia around bottom sides of heart and raffia seat to secure. Position circles at either side of heart; see photo. Glue in place. Wrap raffia around bottom of circles and through raffia seat to secure.

6. Glue four 2" twigs in square centered on underside of raffia seat. For legs, glue four 2" pieces vertically at inside points of square on underside of seat. Glue 2" twig horizontally ½" from bottom of two legs as a support. Repeat, gluing remaining twigs horizontally between legs.

7. Pull pinecones apart and glue separate leaves around seat, overlapping slightly; see photo. Glue statice, caspia, rattan palm and berries around seat and along chair back as desired.

8. To make rocking chair, repeat Steps 5 and 6. Then slightly curve two 5½" twig pieces and glue them to bottom of chair legs; see photo. To decorate, repeat Step 7.

9. To make table, repeat Steps 5 and 6, excluding chair back and using 3" pieces as leg supports. Glue pinecone leaves around table top; see photo. Glue statice, caspia, rattan palm and berries together in desired arrangement. Place on top of table.

10. To make stool top, glue eight 1½" twig pieces together side by side. Glue four twigs in square along edges on underside of stool top. Glue four twigs on top of those. Glue four twigs vertically at inside points of square on underside of stool. Glue 1½" twig horizontally ¼" from bottom of two legs. Repeat, gluing remaining twigs horizontally between legs.

11. Beginning at sides, glue pinecone leaves to top of stool, overlapping slightly toward middle until stool top is covered. Glue grapevine twists to two rosebuds; see photo. Place rosebuds on stool.

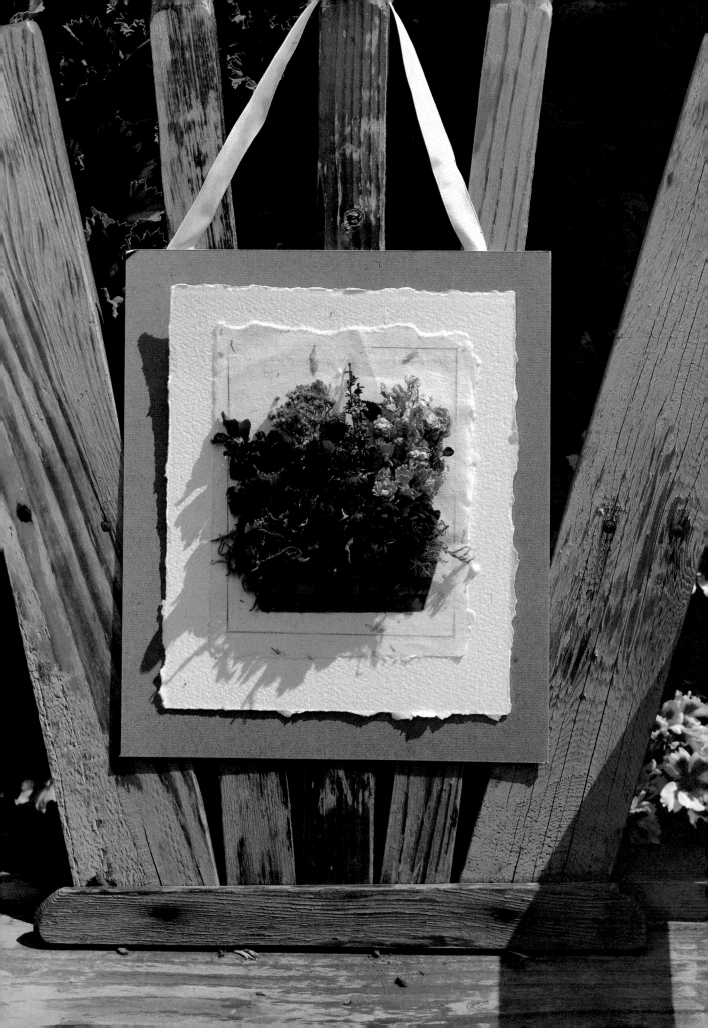

Window Box Portrait

10" x 11½" green mat board

8½" x 10" watercolor paper

6½" x 8" purchased handmade paper

9" of ½" white satin ribbon

Sheet moss

Dried geraniums

Dried titree

Dried baby red rosebuds

Peach brownii

Dried pink larkspur

Acrylic paints: red and brown

Colored pencils: green and brown

Spray adhesive

Hot glue gun and glue sticks

1. On watercolor paper, measure and center 8" x 9½" rectangle and mark lightly with pencil. On handmade paper, measure 6" x 7½" rectangle and mark lightly with pencil. Score along desired lines but do not cut completely through. Tear along score lines.

2. Using colored pencils, draw line ⅛" from all edges of handmade paper. Starting ⅛" from bottom line, draw window box with acrylic paints; see photo. Allow to dry. At top of window box, glue sheet moss. Glue baby rosebuds and dried flowers as desired.

3. Using spray adhesive, attach watercolor paper to mat board. Glue handmade paper to watercolor paper. To make hanger, glue satin ribbon to back of mat board, ½" from each side and ¼" from top edge.

Window Box

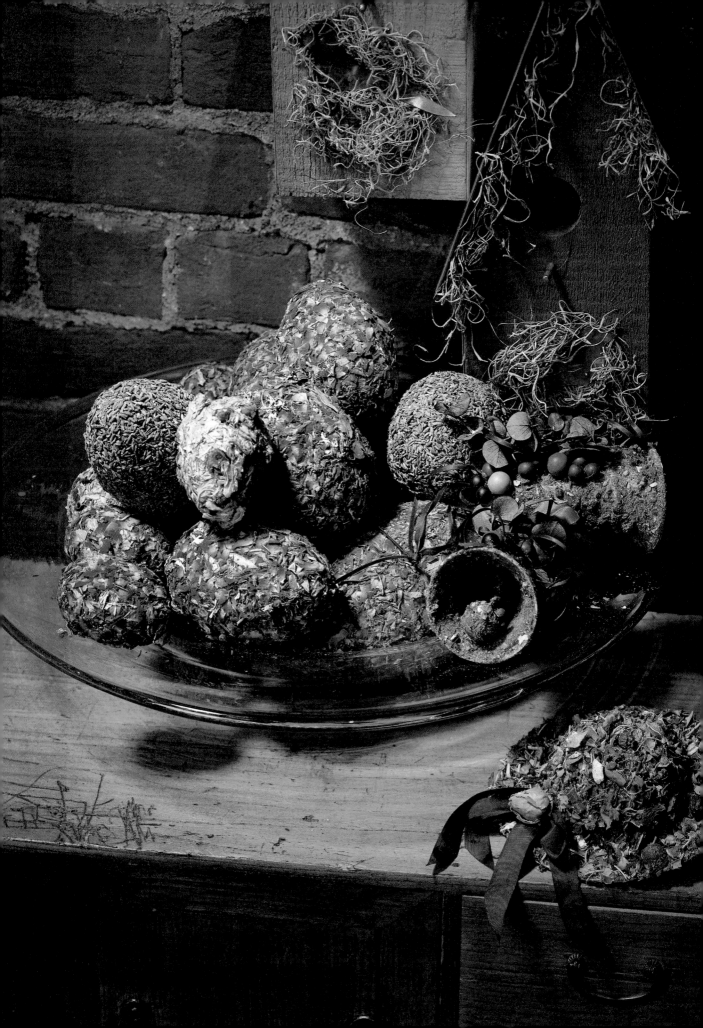

Potpourri Treasures

Two 6" craft foam eggs

Eight 4½" craft foam eggs

Six 3" craft foam eggs

Two 3" craft foam bells

6" straw doll hat

1½ yards of 1" burgundy satin ribbon

3 yards of ⅛" burgundy satin ribbon

Dried white rosebud

8 ounces rose potpourri

4 ounces lavender potpourri

4 ounces sandalwood potpourri

Sprig of berries with leaves

Spray adhesive

Hot glue gun and glue sticks

1. Pour each potpourri into a shallow pan or cookie sheet. Spray adhesive on one egg at a time. Vary potpourri type by egg sizes. Roll in potpourri until form is covered. Set aside.

2. Combine all remaining potpourri into one pan. Repeat Step 1 for bells and hat. Using ⅛" ribbon and berry sprig, tie two bells together.

3. For hat, form a double bow with 1" ribbon. Glue in place. Glue dried rosebud in center of ribbon. Arrange shapes in bowl.

Country Garden Frames

Page 78

10½" x 12½" wood frame

7½" x 9½" wood frame

Sheet moss

Dried roses: red and lavender

Dried yellow roses and rosebuds

Dried salmon statice

Dried lavender rattail statice

1" craft foam egg

2½" craft bird nest

Hot glue gun and glue sticks

Glue moss to frames. Glue lavender rose petals to craft foam egg. Glue egg in nest. Glue red and lavender roses, salmon statice, rattail statice and nest to large frame; see photo. Glue yellow roses and rosebuds to small frame.

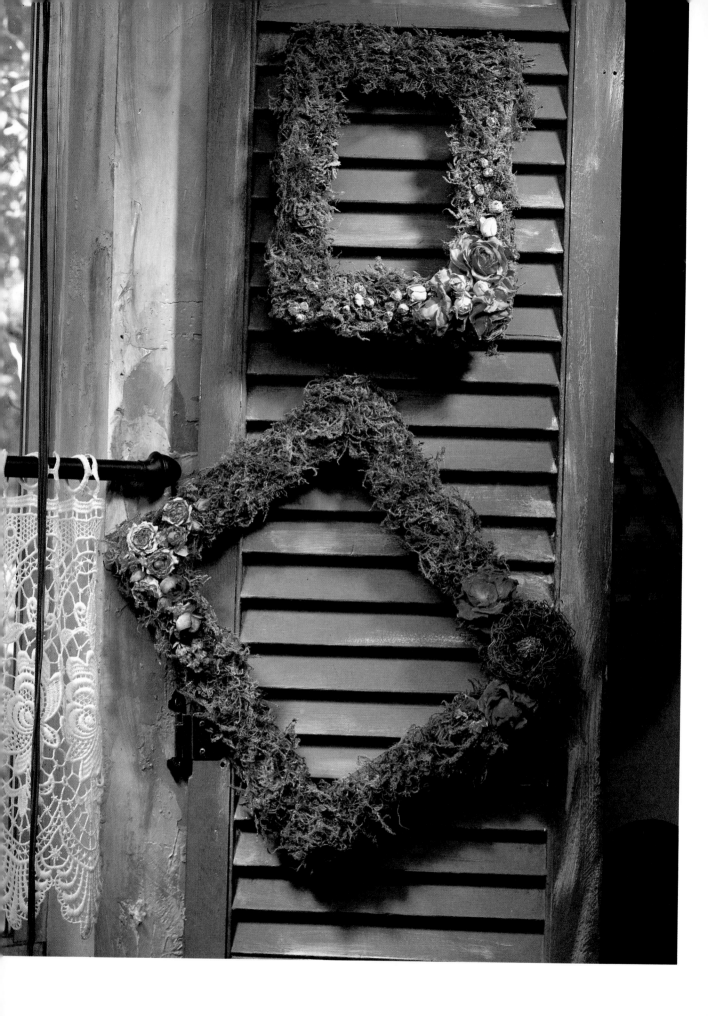

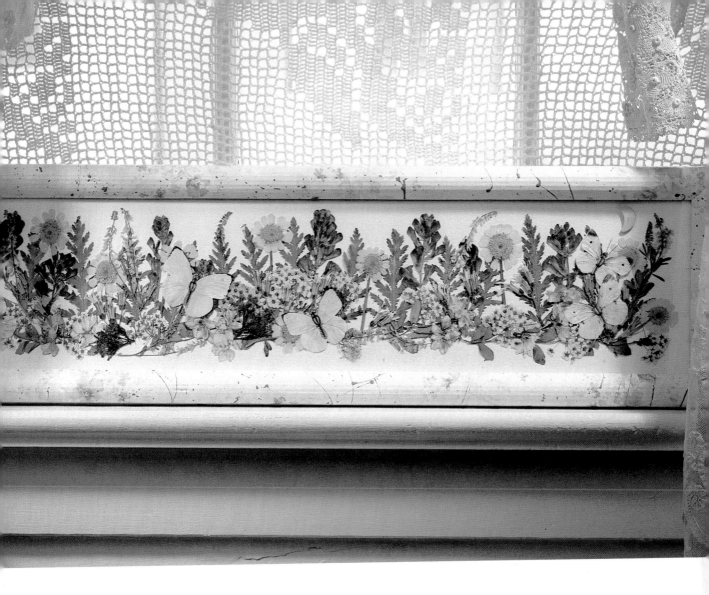

Framed Floral Fantasy

7" x 25" wood picture frame

Floral wrapping paper

7" x 25" watercolor paper

Assorted dried pressed flowers

Five pressed butterflies

Moon-shaped wood bead

Spray adhesive

Acrylic paints to match flowers

Sponges

Paintbrushes

Hot glue gun and glue sticks

1. Measure frame pieces and cut floral wrapping to fit. Attach wrapping paper to frame with spray adhesive. Sponge paint and splatter acrylic paints on wrapped frame. Allow to dry.

2. Glue pressed flowers, butterflies and wood bead to watercolor paper; see photo. Insert paper into frame and secure with backing.

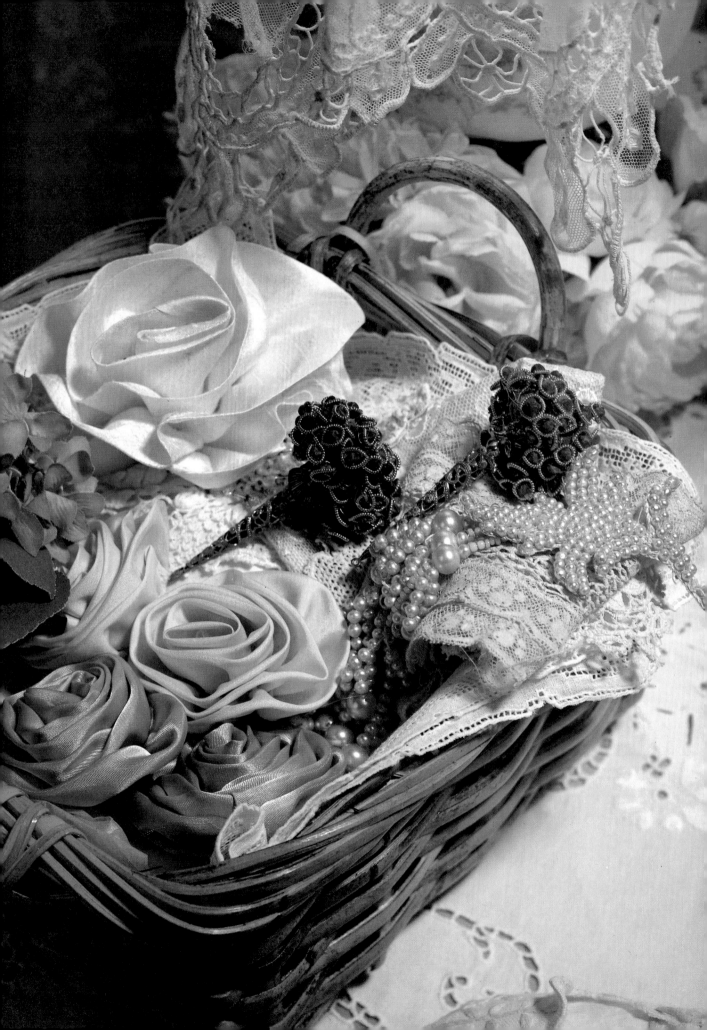

Golden Cloves

Gold metallic florist's wire

Gold metallic No. 7 Jaceron wire

 (see Suppliers)

60 whole cloves

Brown florist's tape

Antique bolo tip

Small gold cherub

1. Cut 60 pieces of florist's wire 5½" long.
Cut 60 pieces of Jaceron wire 1" long.

2. Shape one length of Jaceron into a circle.
Slip florist's wire through ends of circle and
twist to secure. Encircle round clove tip in
Jaceron, then wrap and twist florist's wire
around clove stem. Leave 2½" wire tails.
Repeat with remaining cloves, Jaceron and
florist's wire lengths.

3. Twist free ends of florist's wire together to
make stem. Cover with florist's tape. Using
florist's tape, secure cherub to top of stem
near cloves. Insert stem into bolo tip; secure
with florist's wire.

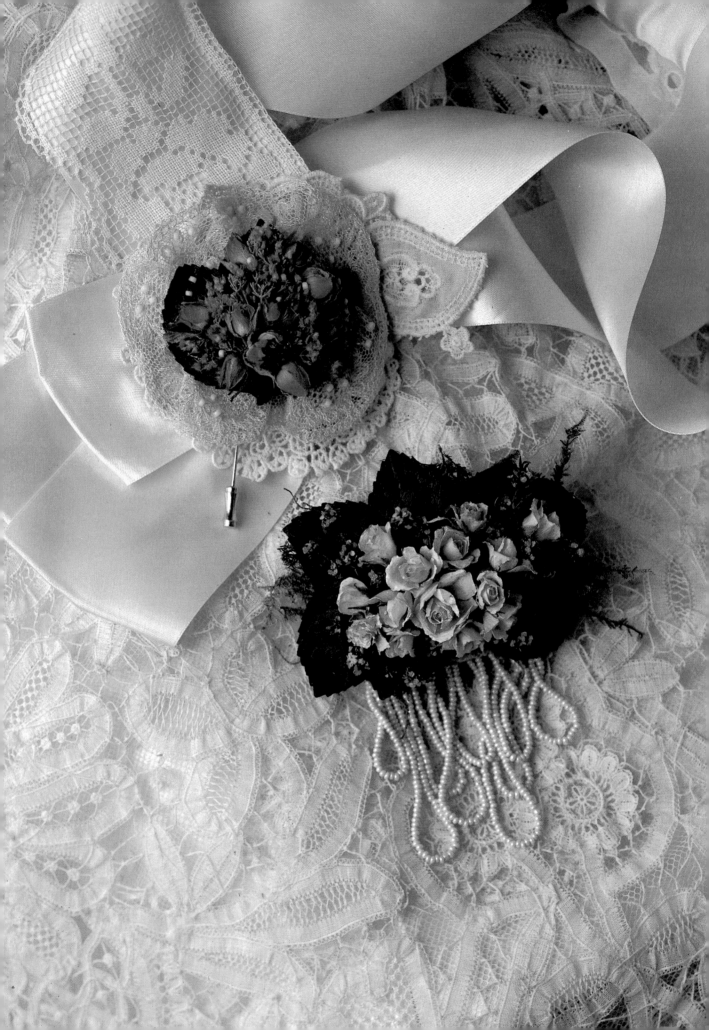

All Dressed Up

White Rose Pin

3" x 2" piece of lightweight cardboard
1 yard of 1½" cream lace
1 yard strand of small ivory beads
Needle and thread
Sheet moss
Seven green velvet leaves
Dried pink flowers
Dried baby white roses
Jewelry pin back
Hot glue gun and glue sticks

Red Rose Pin

½ yard of 1½" antique cream lace
Needle and thread
Small, loose white beads
Three green velvet leaves
Dried pink statice
Dried baby red rosebuds
¾"-square piece of mat board
Stick pin with flat round face
Tacky glue
Hot glue gun and glue sticks

1. To make white rose pin, wrap lace around cardboard, beginning and ending at back. Glue at back.

2. Secure thread in lace at bottom of cardboard piece ½" from edge. String enough beads to make a 1½" loop. Secure thread in lace at bottom edge again and string enough beads to make a 2¼" loop. Repeat until nine similar loops are formed. Secure end of thread.

3. Glue moss to front. Attach leaves, flowers and roses; see photo. Glue jewelry pin horizontally to back of lace-covered cardboard.

4. To make red rose pin, sew gathering threads on one edge of cream lace, folding ends under. Pull lace into a circle, distributing fullness evenly. Tacky glue gathered edges together to secure.

5. Hot glue one leaf at center of lace circle. Glue remaining leaves to either side of first. Glue statice, then rosebuds; see photo. Tacky glue beads to lace and throughout flowers.

6. Hot glue mat board piece to back center of lace. Glue stick pin to back of mat board.

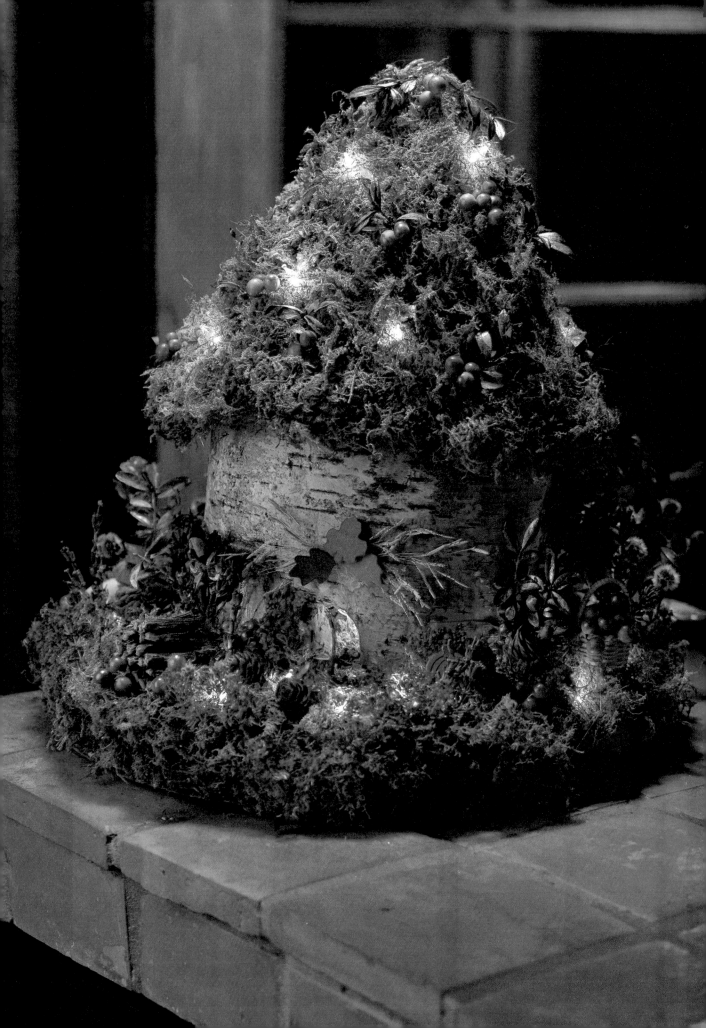

Autumn Hideaway

Some cardboard, tree bark and ingenuity make a base for three seasonal cottages that will add a magical touch to any home. Experiment with favorite colors and ornaments to individualize each project. See Winter Wonderland and Spring Bungalow on pages 86-88.

12"-diameter flat woven basket lid

12" circle of mediumweight cardboard

7" x 20" piece of lightweight cardboard

20" x 5" hollow birch bark trunk

String of small white lights

Masking tape

Sheet moss

Three small wood leaves

Assorted dried leaves and flowers

Small dried berries

Miniature pinecones

Miniature basket

Twelve 1" twig pieces

Hot glue gun and glue sticks

1. To make base, cut a small hole in middle of basket lid. Push string of lights through hole inside lid, leaving about eight lights on plug end dangling free at bottom. Cut about eight holes, the size of small light bulbs, at random in lid. Push lights through holes. Tape wires to inside of lid. Glue lid, rim down, to cardboard circle, making small space in rim for plug end to come out back. Glue moss to lid and rim.

2. Cut ½" x 1" doorway in birch bark trunk, rounding top of doorway and leaving one side of door joined. Glue trunk in middle of moss-covered lid. Tape one light inside bark next to door. Glue moss around bark piece.

3. To make roof, roll lightweight cardboard into cone shape. Glue seam on inside. Cut about eight holes, the size of small light bulbs at random in cone. Push lights through holes. Tape wires to inside of cone. Glue moss to outside of cone.

4. Place roof on top of trunk; glue in place. Decorate roof with leaves and berries. Glue three wood leaves over the door. Decorate base with flowers, pinecones, berries and leaves.

5. Glue berries into miniature basket. Glue basket on moss near cottage. Stack and glue twigs to resemble wood stack near cottage.

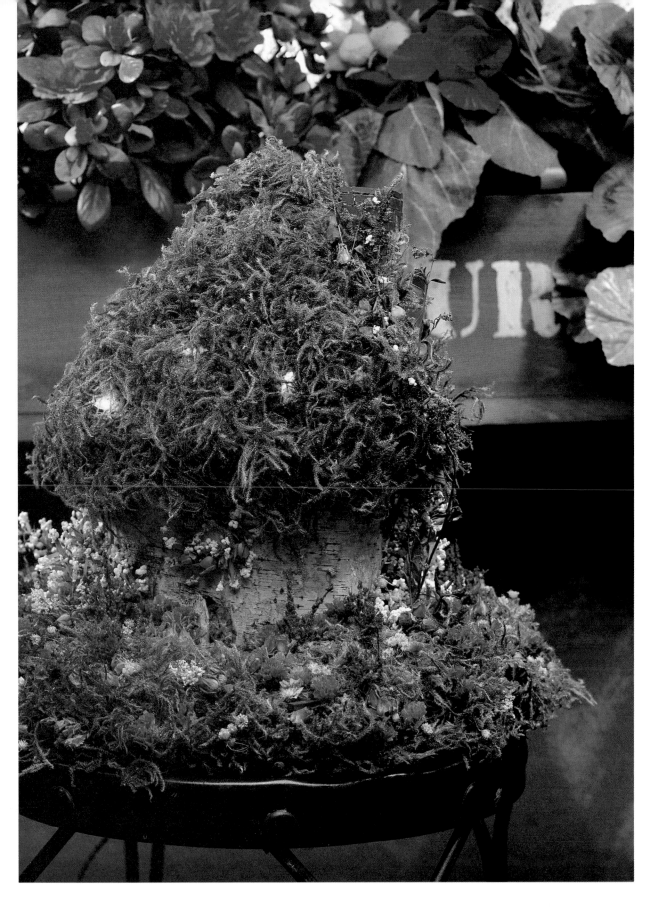

Winter Wonderland

Page 86

First seven materials of Autumn Hideaway
 on page 85
2½" silver star ornament
Small pinecones
Dried white rattan palm
Dried straw flowers
Assorted dried flowers
Holly trim snow
Silver spray glitter
Hot glue gun and glue sticks

1. Complete Steps 1-3 of Autumn Hideaway.
Place roof on top of trunk; glue in place.
Glue star to top of roof.

2. Using rattan palm, make a 2" wreath over
door. Decorate base with pinecones, rattan
palm, strawflowers and dried flowers; see
photo.

3. Spray house and grounds with holly trim
snow and silver glitter.

Spring Bungalow

Page 87

First seven materials from Autumn Hideaway
 on page 85
Dried baby pink rosebuds
Dried purple statice
Dried flowers: blue, yellow and mauve
Dried miniature purple berries
Silk miniature white berries
Sixteen 1" scale model clay bricks
Acrylic paints: red, green and cream
Sponges
Thin paintbrush
Hot glue gun and glue sticks

Country Comfort

5½" x 5" purchased willow chair
2 yards of ⅝" peach organdy ribbon
Sheet moss
Two silk peach roses
Mushroom bird
Dried baby red rosebuds
Assorted dried berries
Pinecones
Florist's wire
Silver spray glitter
Hot glue gun and glue sticks

1. Glue moss to chair seat and back. Glue
silk roses, mushroom bird, dried rosebuds,
berries and pinecones to moss; see photo.

2. To make bow, cut ribbon into two equal
lengths. With one length, make five 6" loops
and secure together at middle with florist's
wire. Repeat with remaining length, making
five 4" loops for smaller bow. Glue large
bow to top of chair and small bow to seat of
chair.

3. Spray decorated chair with glitter.

1. Complete Steps 1-3 of Autumn
Hideway. Place roof on top of trunk; glue in
place. Decorate roof with rosebuds, statice,
flowers and berries; see photo.

2. Sponge paint bricks red and green. Allow
to dry. Using cream, paint lines on 1" bricks
to resemble small bricks; see photo. Glue
bricks in front of door, making pathway.

3. Using baby rosebuds, statice and silk
berries, make a 2" wreath above door.
Decorate base with rosebuds, statice, flowers
and berries.

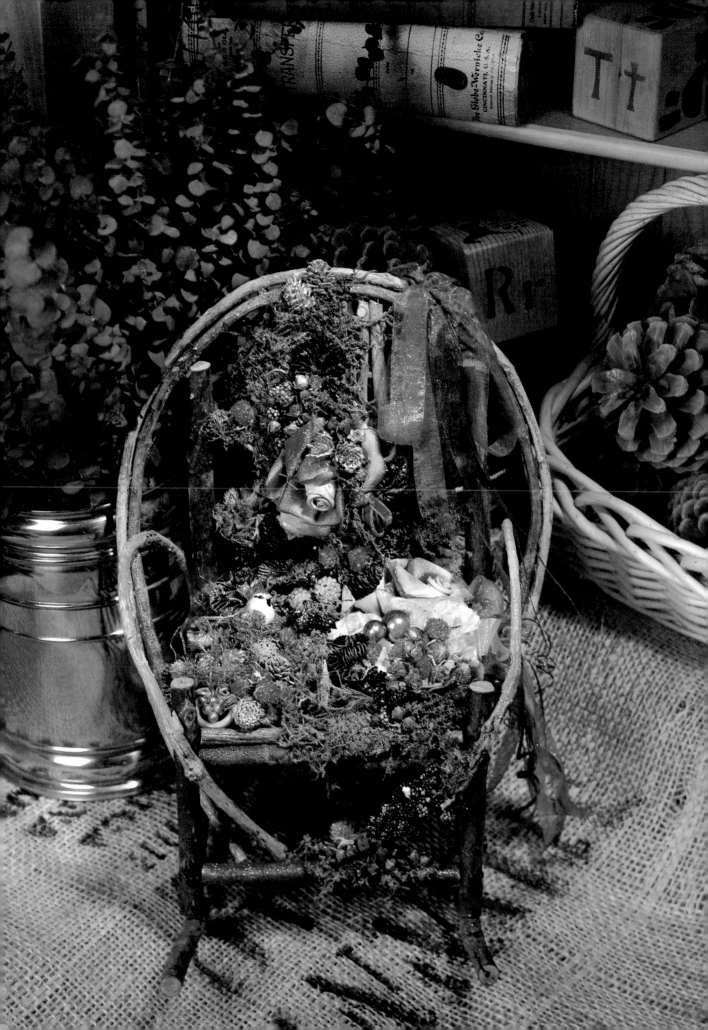

The Circle
Is Unbroken

A welcoming wreath,
whatever its shape, has
no beginning and no end.
One continuous circle
created to decorate a door
or brighten a room—
an enduring symbol that
the home and heart are
always open to visitors
and friends.

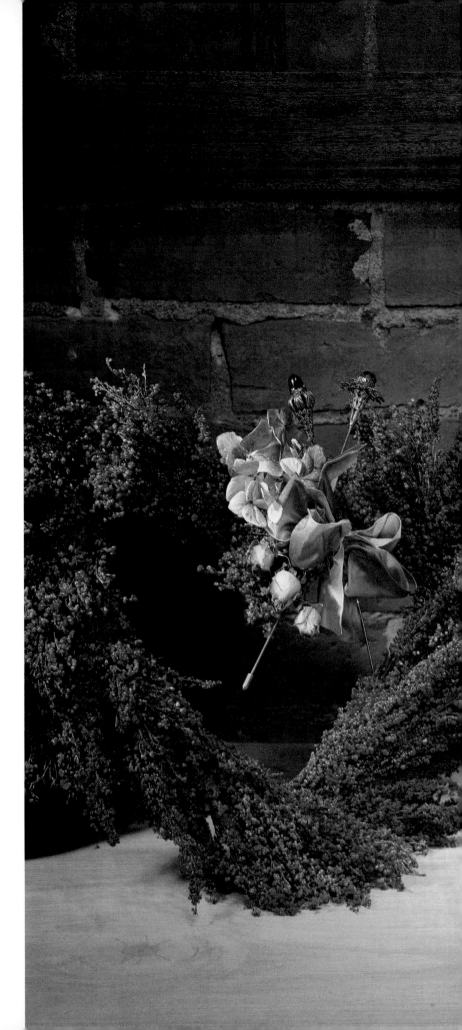

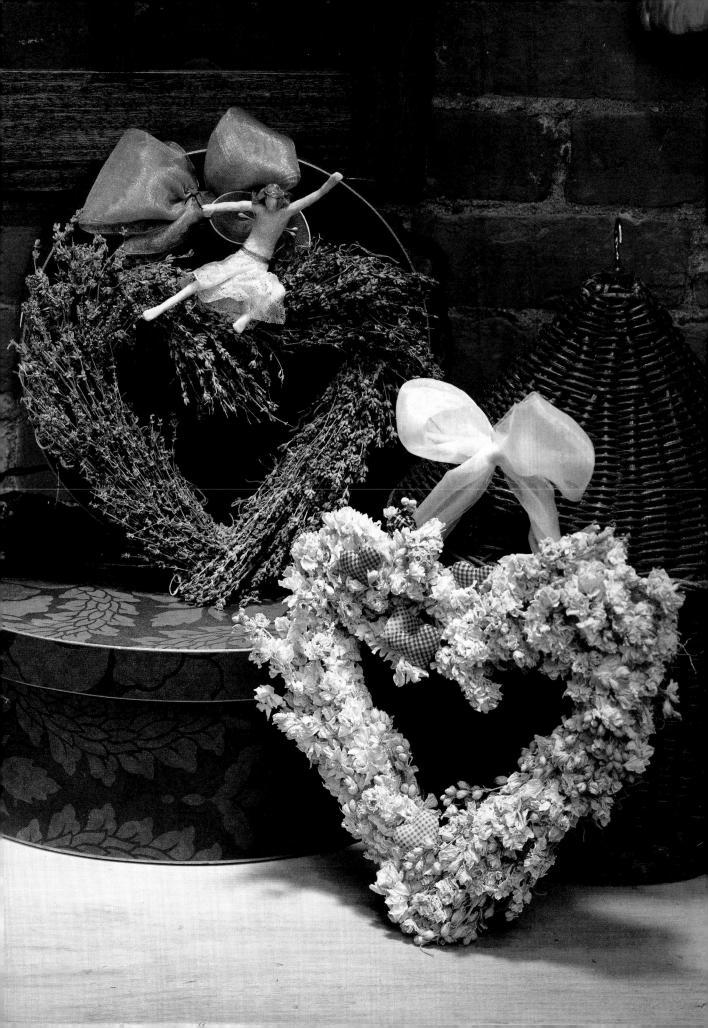

Sweet Hearts

Page 90

Heather Wreath

10" pronged heart-shaped wire wreath
Dried heather
Silk rosebuds
Dried sweet pea
Two antique lapel pins
1 yard of 1" pastel wired ribbon
Florist's wire

1. Wire heather to wreath, crisscrossing stems over prongs. Wire sweet pea and rosebuds together, using excess wire to secure at center.

2. Position lapel pins through flowers and wreath. Tie small bow from ribbon and wire to wreath.

Lavender Wreath

8" pronged heart-shaped wire wreath
Dried lavender
3" purchased figurine
¼ yard of 45" white organdy fabric
Gold florist's wire

1. Using lavender, complete Steps 1 and 2 of Heather Wreath above.

2. Wrap wire around waist of figurine and secure to wreath.

3. With right sides facing, fold organdy in half lengthwise and sew seam. Turn. Tie organdy into a bow with two long tails. Wire ends of tails to arches of wreath; see photo.

Larkspur Wreath

8" pronged heart-shaped wire wreath
Dried larkspur
¼ yard of 45" white organdy fabric
¼ yard red gingham fabric
¼ yard blue gingham fabric
White thread
Polyester stuffing
Florist's wire
Hot glue gun and glue sticks

1. Complete Steps 1 and 2 of Heather Wreath and Step 3 of Lavender Wreath.

2. Cut six small hearts from blue gingham and eight large hearts from red gingham according to patterns.

3. With right sides facing, stitch two small hearts together, leaving a small opening. Turn. Stuff. Slipstitch opening closed. Repeat with remaining small hearts and large hearts. Glue stuffed hearts to wreath; see photo.

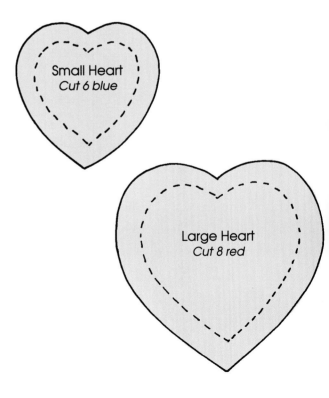

Small Heart
Cut 6 blue

Large Heart
Cut 8 red

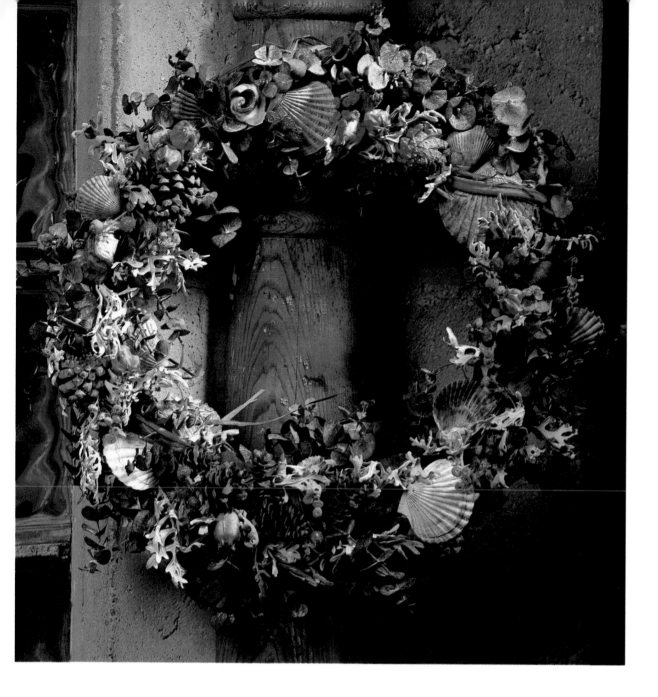

Sea Breezes

15" round grapevine wreath

Dried aqua eucalyptus

Assorted seashells

Small pinecones

Dried pepper berries

Dried artemisia

Assorted dried flowers

Hot glue gun and glue sticks

Purchase a grapevine wreath or, to make one, see General Instructions on page 157. Cut eucalyptus into 3"-long pieces; glue to front of wreath. Glue on remaining materials; see photo.

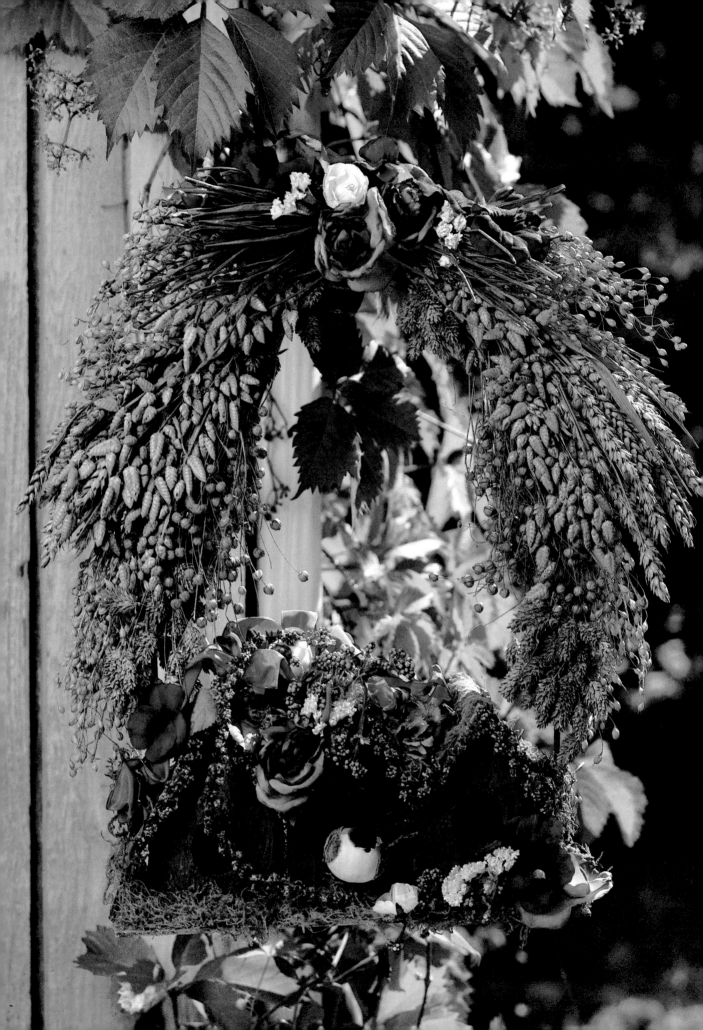

A Home with Heart

30" heavy craft wire
Three purchased birdhouses
Sheet moss
3½" x 12" plywood
Green wheat
Green rattail wheat
Green wild wheat
Green dill weed
Green docket
Green raffia
Three silk lavender roses
Three dried yellow statice
Eight silk purple pansies
1½ yards of purple wired ribbon
Two paper white flowers
Dried purple berries
1¼ yards of dried pink flower garland
Two mushroom birds
Blue acrylic paint
Paintbrush
Florist's wire
Hot glue gun and glue sticks

1. Glue birdhouses together. Paint blue dots to resemble flowers around holes in birdhouses; see photo. Allow to dry.

2. Bend craft wire into a horseshoe shape. Drill one hole each in tops of outer birdhouses to accommodate wire. Glue moss, then birdhouses to plywood. Insert wire. Glue to secure.

3. Using florist's wire, wrap small bunches of wheat, rattail wheat, wild wheat, dill weed and docket together. Attach to craft wire with florist's wire; see photo.

4. At top of wreath, glue raffia, roses, statice and pansies as desired. Tie wired ribbon into a bow and glue to wreath.

5. Glue moss to birdhouse roofs. Glue paper flowers, berries and mushroom birds as desired. Glue garland to front roof edges. Loop wired ribbon and glue to top of birdhouse; see photo.

Backwoods Birdhouse

Page 96

12" oval grapevine wreath
24 dried lavender sprigs
Twelve lemon leaf sprigs
Purchased bark birdhouse
Two dried pink roses
Miniature white strawflowers
Three dried berry sprigs
Five acorns
Hot glue gun and glue sticks

1. Purchase a grapevine wreath or, to make one, see General Instructions on page 157. Arrange lavender sprigs and lemon leaf sprigs on wreath. Glue to wreath as desired.

2. Glue bark birdhouse on top of combined stems and leaves. Position roses and glue in place; see photo.

3. Glue strawflowers, berries and acorns to wreath as desired.

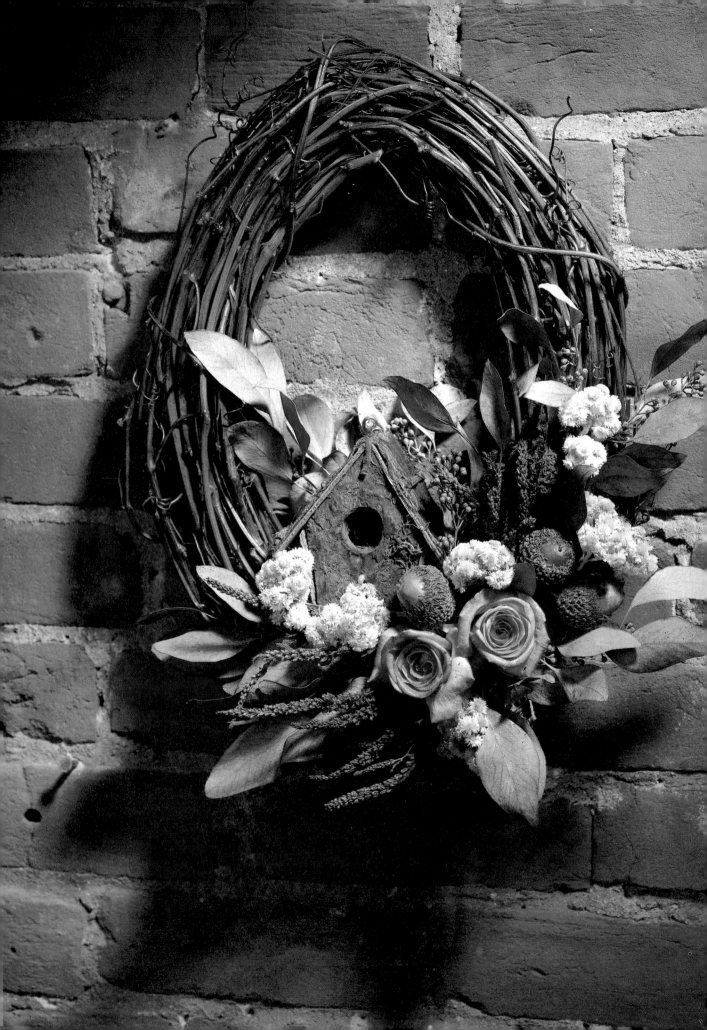

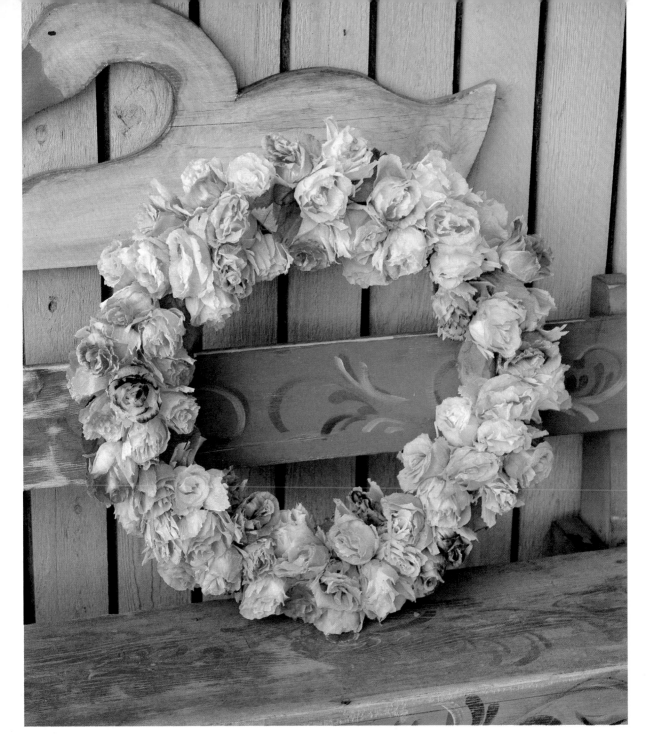

Fiesta of Roses

18" round grapevine wreath

80 brightly colored crepe-paper roses

Twelve paper leaves

White acrylic paint

Paintbrush

Hot glue gun and glue sticks

Purchase a grapevine wreath or, to make one, see General Instructions on page 157. Paint wreath white. Allow to dry. Put roses and leaves in sun to fade; glue to wreath.

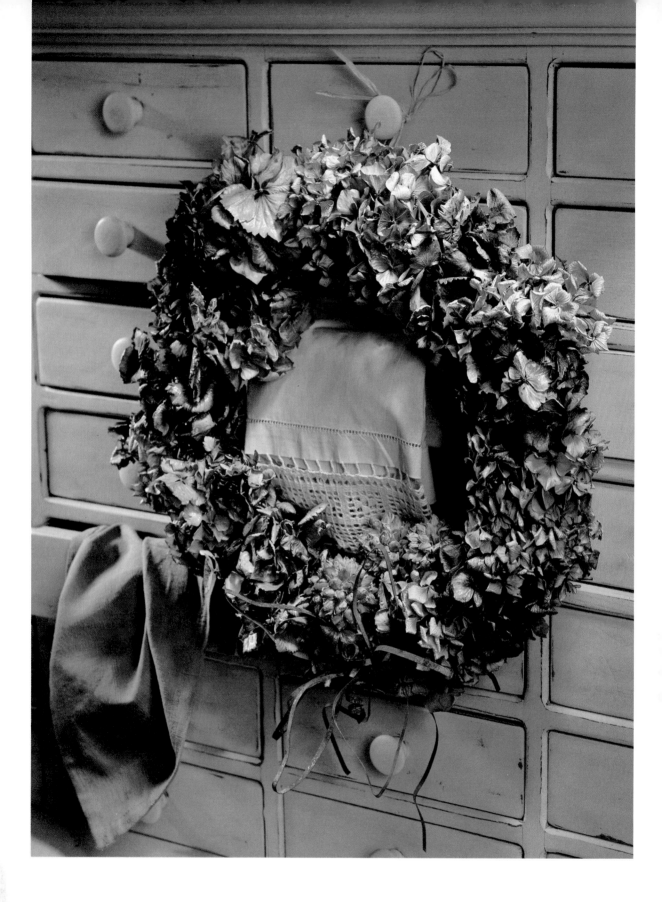

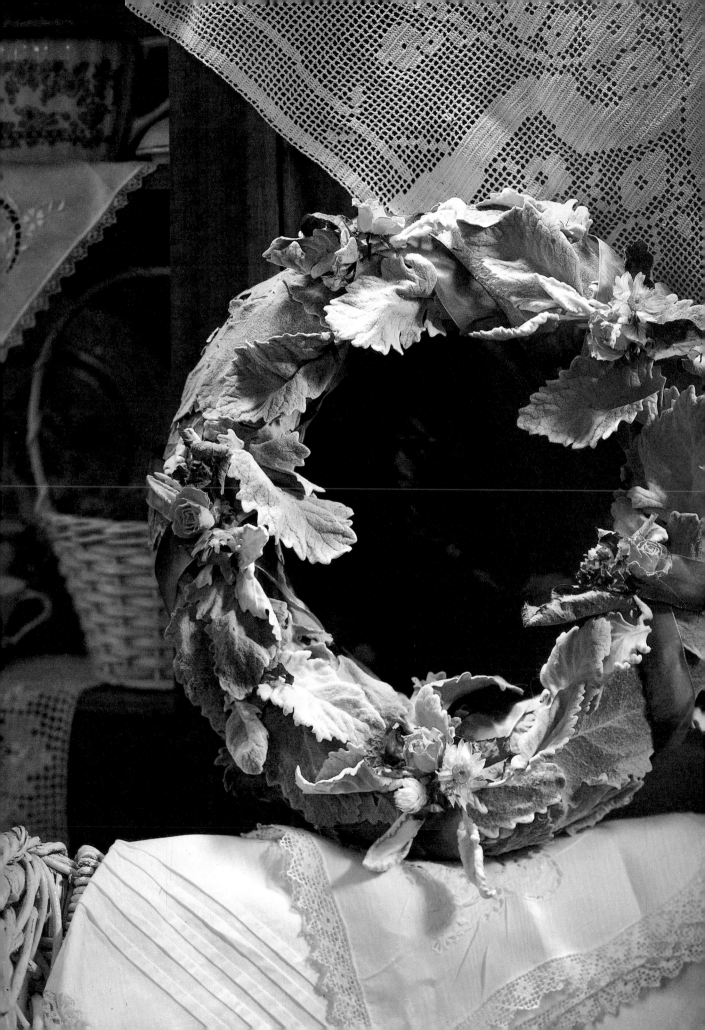

Hydrangea Beauty

Page 98

15" oval grapevine wreath

Sheet moss

Assorted dried hydrangea

120 dried baby pink rosebuds

2 yards of ¼" metal stripping

Florist's tape

Florist's wire

Hot glue gun and glue sticks

1. Purchase a grapevine wreath or, to make one, see General Instructions on page 157. Glue moss to wreath.

2. Tape small clusters of hydrangea together with florist's tape. Wire hydrangea clusters to wreath, covering completely.

3. To make a rose ball, tape about 40 baby rosebuds together, rounding top and sides. Repeat to make two more. Wire rose balls to bottom right side of wreath; see photo.

4. Form a bow out of metal stripping, having three loops on each side and leaving 6" tails. Glue bow at bottom center.

Lamb So Soft

Page 99

10" craft foam wreath

60 dried lamb's ear leaves

3 yards of 1½" peach/green wired ribbon

Five dried peach rosebuds

Five silk white daisies

Five dried white strawflowers

Dried lavender lilacs

Hot glue gun and glue sticks

Glue lamb's ear leaves to wreath. Wrap ribbon around wreath twice, crisscrossing over leaves. Glue rosebuds, daisies, strawflowers and lilacs to wreath; see photo.

Spring Fling

15" round grapevine wreath

Twenty dried yellow daffodils

Twelve dried leaves

Six dried white daffodils

Four dried yellow tulips

2 yards raffia

Hot glue gun and glue sticks

Purchase a grapevine wreath or, to make one, see General Instructions on page 157. Glue daffodils, tulips and leaves to wreath. Wrap raffia around wreath and tie a bow.

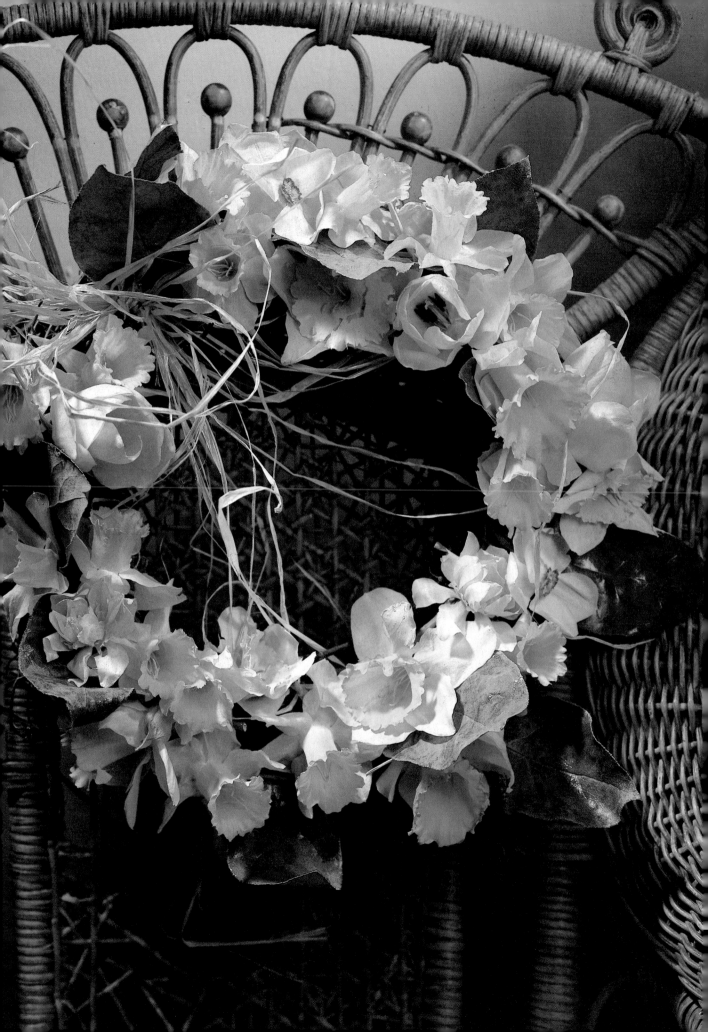

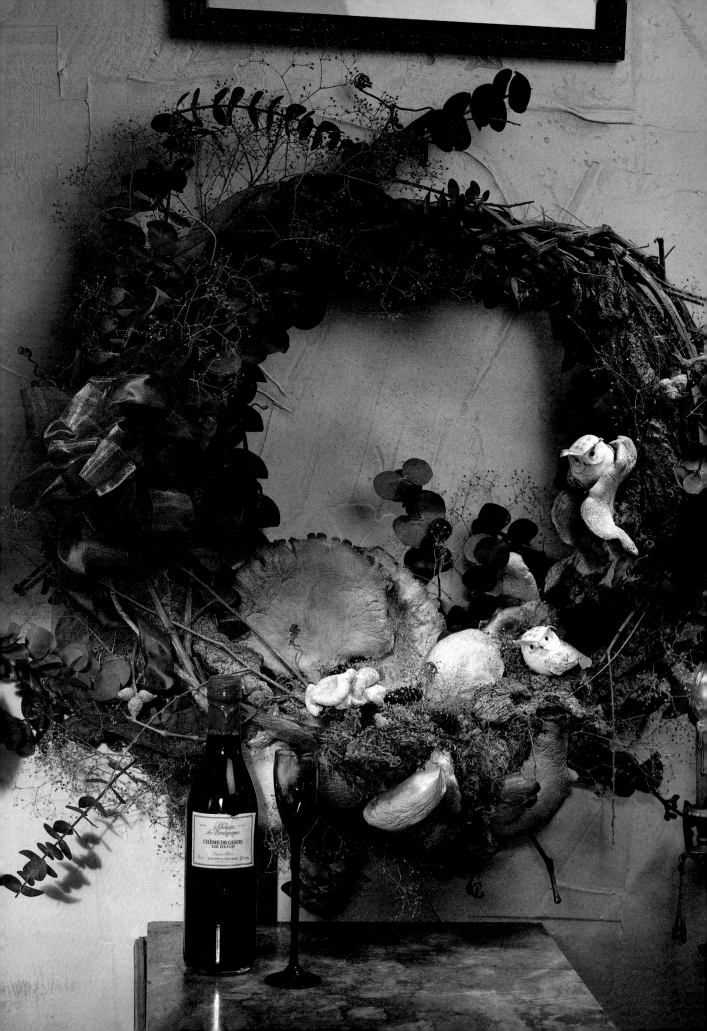

Forest Shelter

24" round grapevine wreath
Ten wild mushrooms
Bark pieces
Sheet moss
Dried red eucalyptus
Baby's breath
Dogwood seedpods
Pinecones
Willow twigs
Two mushroom owls
3½ yards of 1" green wired ribbon
3½ yards of 1" green organdy ribbon
Silica gel crystals
Florist's wire
Hot glue gun and glue sticks

1. Pick large mushrooms and dry according to silica gel instructions. For more on drying, see General Instructions on page 157.

2. Purchase a grapevine wreath or, to make one, see General Instructions on page 157.

3. Glue moss to bark. Glue bark to bottom sides and inside center of wreath. Add mushrooms to moss at bottom center; see photo. Glue eucalyptus, baby's breath, seedpods, pinecones, willow twigs and owls to wreath; see photo.

4. Handling wired ribbon and organdy as one, leave a 3" tail and make one 4" loop. Pinch at bottom and make 14 additional loops, leaving another 3" tail. Wrap florist's wire around bottom to secure loops. Glue bow to top left corner of wreath.

Copper Treasure

Page 106

12" x 36" copper sheet
20 feet No. 6 gauge copper wire
20 feet No. 8 gauge copper wire
20 feet No. 12 gauge copper wire
50 feet No. 18 gauge copper wire
Steel wool
Nail
Old scissors
Wire cutters
8 ounces green patina paint
Acrylic paints: royal copper and burgundy
Paintbrushes
Metal glue
Clear resin spray

1. Roughen one side of copper sheet with steel wool. Using a nail, trace leaf patterns on pages 104 and 105, including veins, onto copper sheet. Using old scissors, cut three large leaves, four medium leaves, eight small leaves and five tiny leaves.

2. With wire cutters, cut twenty 6" lengths of No. 18 gauge wire; glue one onto each leaf.

3. Paint centers of each leaf two or three times with green patina paint. Allow to dry. With a dry brush, feather paint remainder of leaf with royal copper paint. Allow to dry. With a dry brush, feather paint burgundy on edges of each leaf. Allow to dry. Shape leaves by bending.

4. Bend different gauge wires into wreath shape. Make vine curls by wrapping eight 12" lengths of No. 18 gauge wire around pencil. Glue leaves and leaf curls to wreath.

5. Spray leaves with clear resin. Dry brush copper leaf curls and wreath with burgundy.

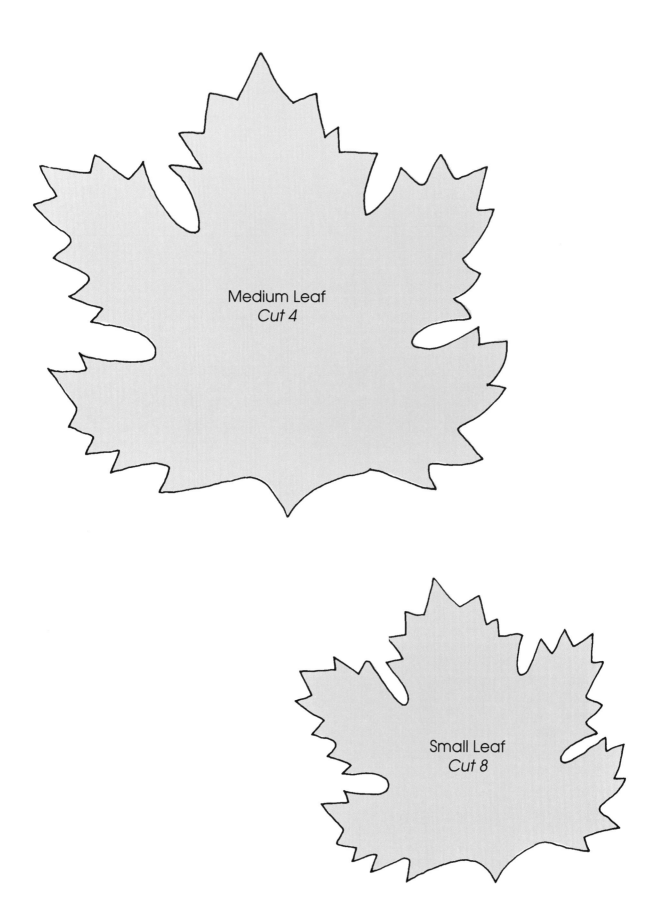

Medium Leaf
Cut 4

Small Leaf
Cut 8

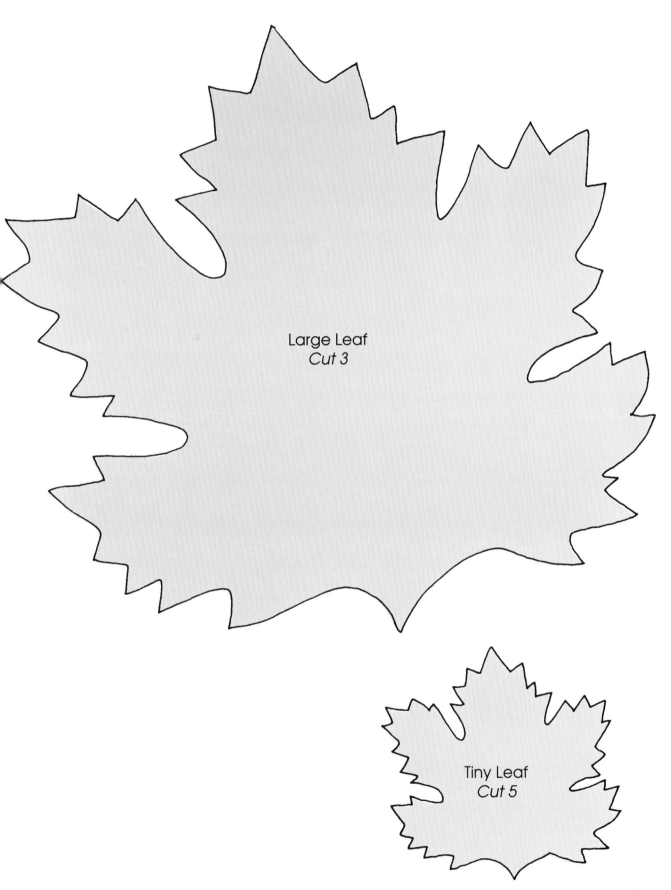

Large Leaf
Cut 3

Tiny Leaf
Cut 5

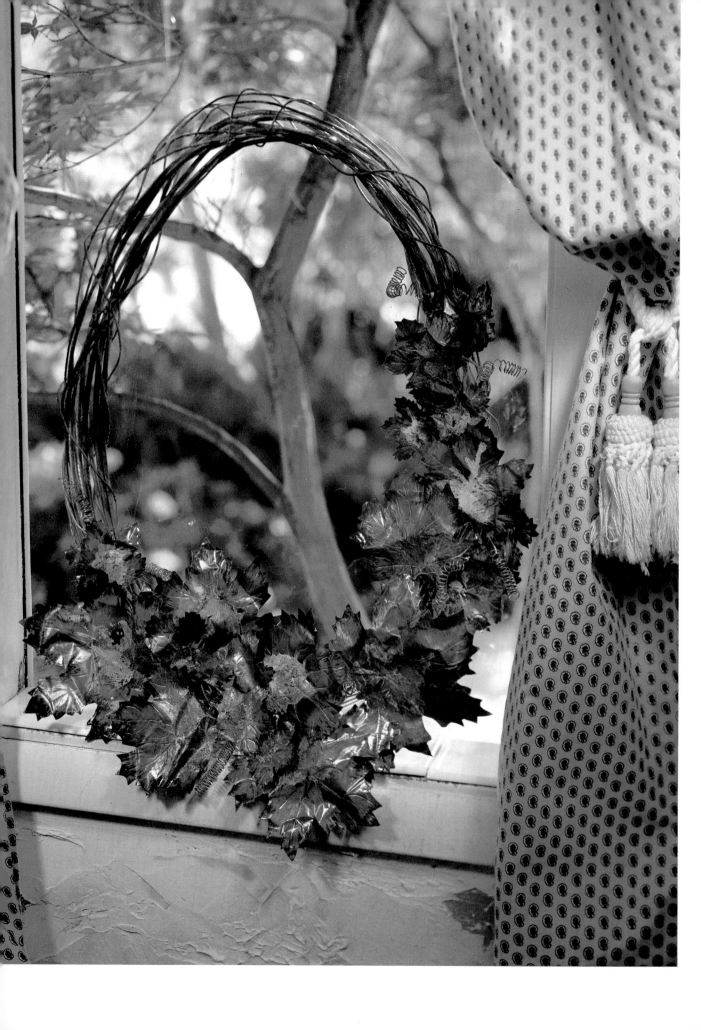

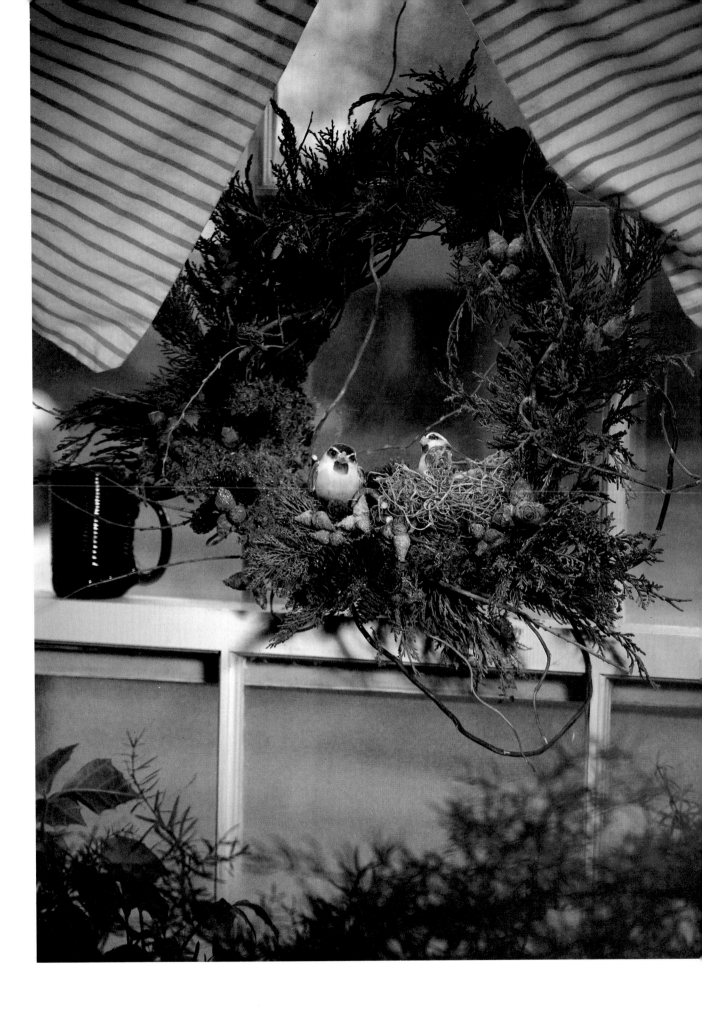

Love Nest

Page 107

Corkscrew willow branches

Evergreen sprigs

Spanish moss

Sheet moss

Two mushroom birds

Baby pinecones

Dogwood seedpods

Green spray paint

Florist's wire

Hot glue gun and glue sticks

1. Spray paint evergreen sprigs green. Allow about three days to dry.

2. Twist willow branches together in shape desired for wreath and secure with florist's wire. Add larger willow branches to bottom of wreath horizontally; see photo.

3. Glue evergreen sprigs, pinecones and seedpods to wreath; see photo.

4. Glue sheet moss to large willow branches. Glue one bird to sheet moss. Shape a nest from Spanish moss and glue second bird inside nest.

Last Rose of Summer

8" heart-shaped craft foam wreath
Sheet moss
Assorted dried rosebuds
1 yard of 6" organdy ribbon: pink, red
 and burgundy
1½ yards of 1½" ivory satin ribbon
Florist's wire
Hot glue gun and glue sticks

1. Glue moss over entire foam base. Glue rosebuds over moss on front; see photo.

2. Form one length of organdy into several loops and secure bow with florist's wire. Repeat with remaining organdy ribbon lengths and satin ribbon. Wire bows together, leaving some wire free; secure bows to wreath with wire.

May Flowers Wreath

Page 110

15" round grapevine wreath

2 yards of 1¼" green/pink wired ribbon

Nine dried lemon leaf sprigs

Five pink and seven red dried peonies

Dried orange blossoms

Florist's wire

Hot glue gun and glue sticks

1. Purchase a grapevine wreath or, to make one, see General Instructions on page 157. Glue lemon leaf sprigs, peonies and orange blossoms to wreath; see photo.

2. To make a bow with wired ribbon, secure ten or more loops with florist's wire, leaving about 5" tails. Attach bow to wreath with free wire ends.

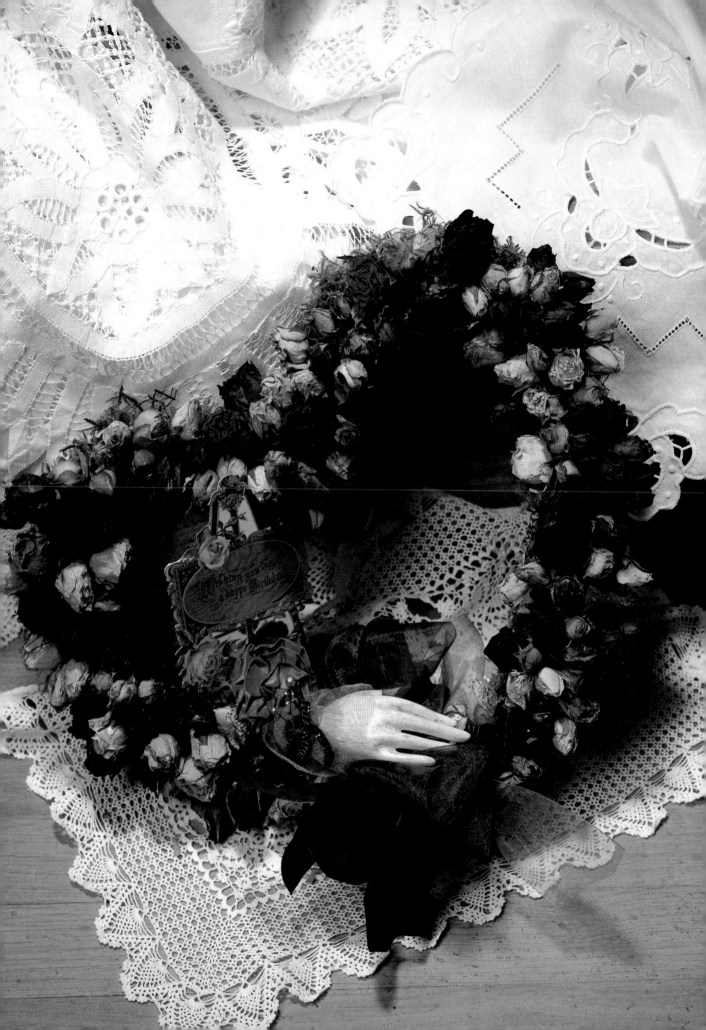

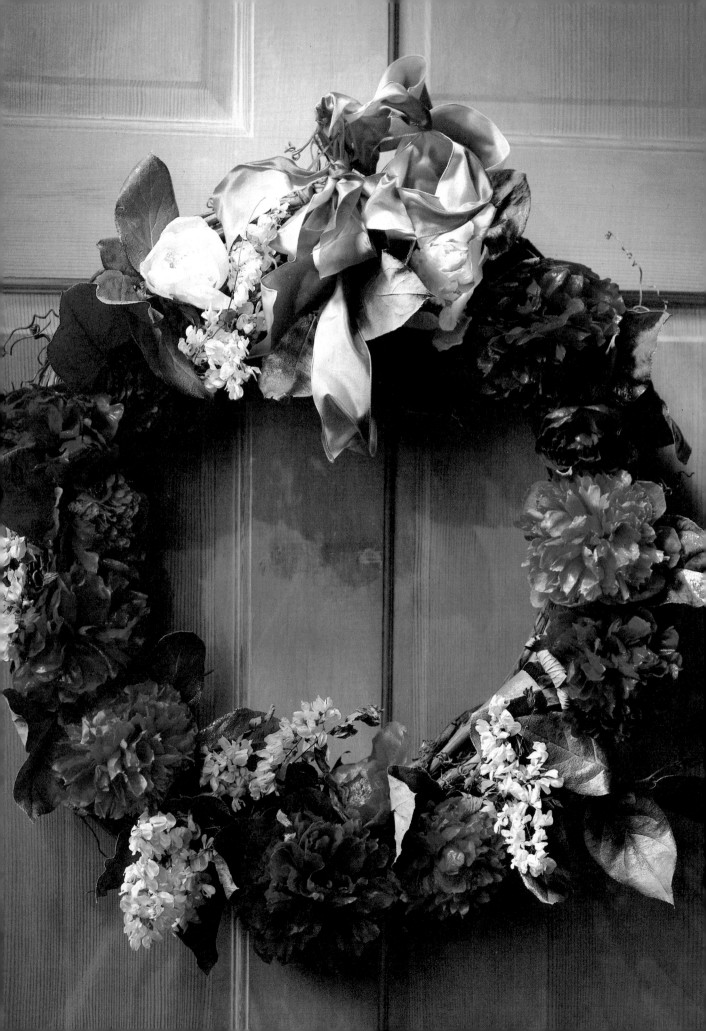

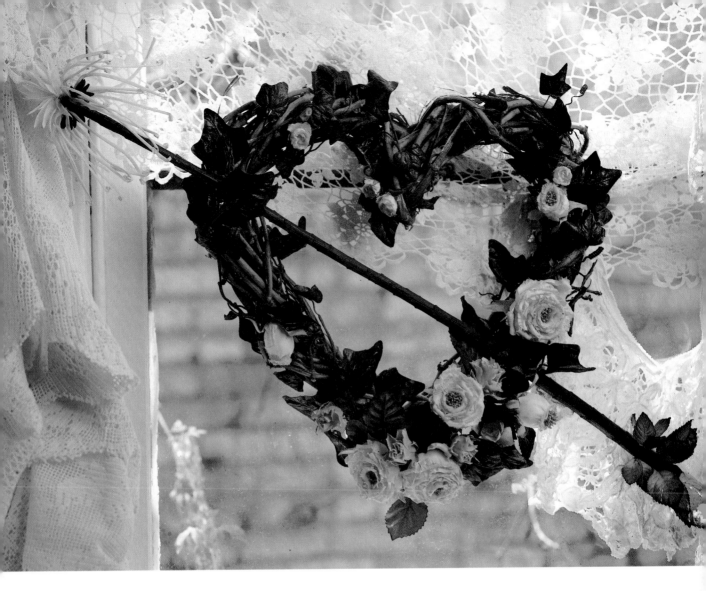

Cupid's Arrow

15" heart-shaped grapevine wreath

29" length of willow branch

15 paper rose leaves

Silk pink spider mum

Waxed ivy

Four silk pink cabbage mums

Four silk pink cabbage mum buds

Four silk pink baby roses

Five dried pink roses

Brown acrylic paint

Paintbrush

Florist's tape

Hot glue gun and glue sticks

1. Purchase a grapevine wreath or, to make one, see General Instructions on page 157. Paint willow branch brown. Allow to dry.

2. Using florist's tape attach rose leaves to wide end of willow branch and spider mum to narrow end. Touch up tape with brown paint to blend with willow. Allow to dry.

3. Weave ivy through wreath; see photo. Glue roses and mums to wreath as desired.

Clinging Vines

4 yards silk ivy

25 feet No. 22 gauge galvanized wire

Assorted silk and plastic berries

Two small plastic pears

White silk statice

White silk flowers

Purple silk hydrangea

Purple paper flowers

Florist's wire

Clear resin spray

Hot glue gun and glue sticks

1. Cut 12½ feet of galvanized wire. Wrap three times into an oval shape. Attach one end of other length of 12½ feet of wire to bottom of oval shape, wrapping back and forth, up and down to form a thick basket-like base.

2. Weave silk ivy through front of wreath, covering all galvanized wire and securing with florist's wire.

3. Spray six coats of clear resin over ivy. Allow to dry. Glue berries, plastic pears, paper flowers and silk flowers to wreath.

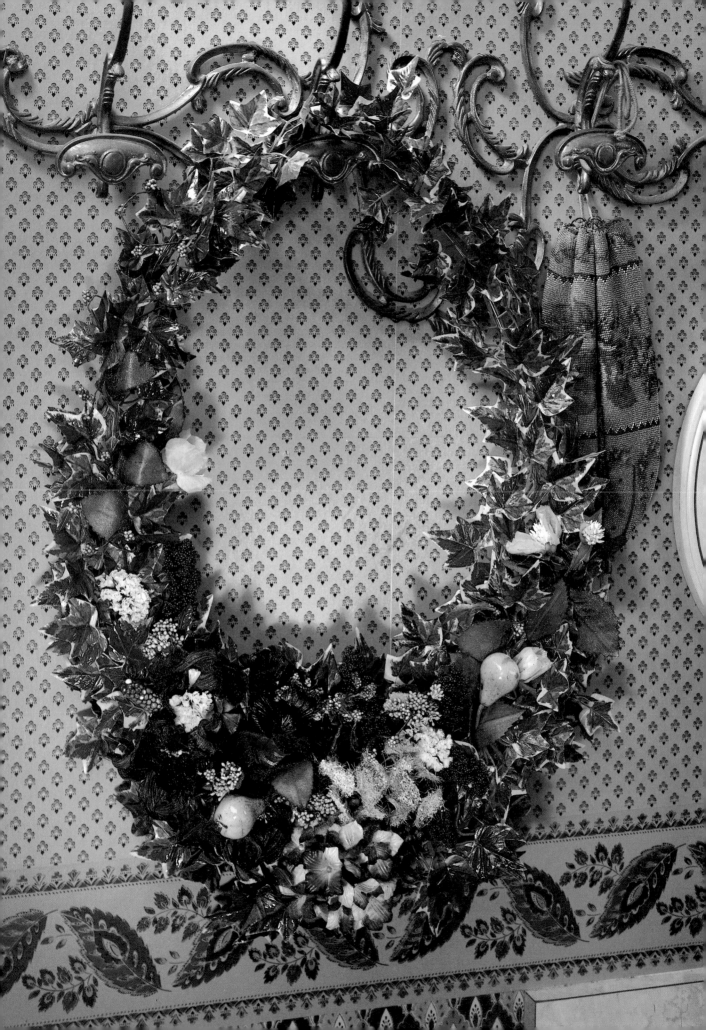

Every Day's A Holiday

Thanksgiving and Christmas
beckon us to express
gratitude and joy. Then
there are those simple days
that also deserve our
recognition, like a soft
spring morning when
you can breathe deeply
and feel the air skip
through your blood or a
lazy summer afternoon
when all you want to do is
spit watermelon seeds at
your toes. Celebrate each
day, nurture the ordinary
and reap a friend within.

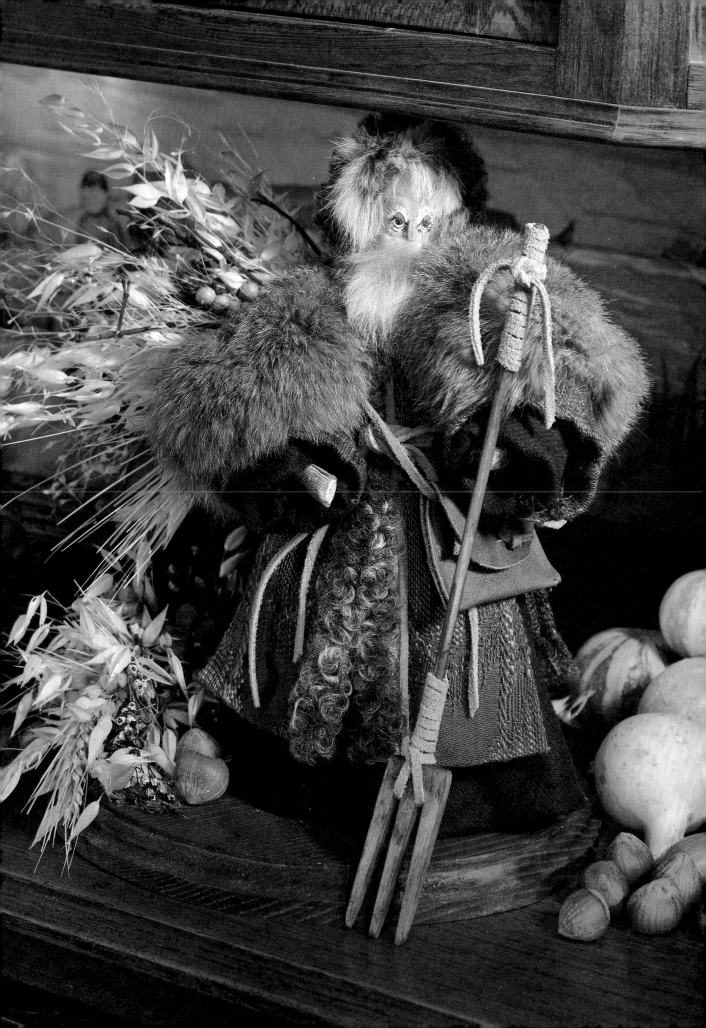

The Harvester

Large walnut in shell

1 yard of purple wool fabric

1 yard of multicolored wool fabric

8" square of tan leather

4" x 7" piece of brown leather

2½ yards of ⅛" suede leather strip

5" x 10" piece of fake curly fur

6" square of gray fur

7" x 10" piece of brown fur

5½" x 1½" piece of driftwood

Eight 7" twigs

Two 3" twigs

Two 2" twigs

10" wood fork

9" round stained oak base

Dried wheat

Dried berries

Dried rattan palm

Three small pinecones

Acrylic paints: peach, white and brown

Sponge

Fine paintbrush

Tracing paper

Carbon paper

Dressmaker's pen

Hot glue gun and glue sticks

1. Sponge paint walnut peach. Allow to dry. Trace face pattern on page 118. Holding walnut vertically, transfer pattern. Paint eyes. Glue small piece of twig to walnut for nose; paint peach. Allow to dry.

2. Trace, transfer and cut two frock patterns and two frock sleeves from purple fabric. From multicolored fabric, cut one coat back, one left front, one right front, two sleeves and two hood pieces. Patterns include ¼" seam allowance.

3. From tan leather, cut one bag and one bottom. From brown leather, cut one satchel pattern. Cut suede leather strip into one 28" length, two 18" lengths, two 10" lengths and one 2" length.

4. From curly fur, cut one ⅜" x 10" strip and three ⅜" x 6" strips. From gray fur, cut one 1" x 2" piece and one 4" x 6" piece. From brown fur, cut a collar-shaped piece (see Diagram A).

5. For purple frock, stitch side and shoulder seams with right sides facing. Turn. Leave neck and sleeve edges raw. Stitch narrow hem on bottom. Set aside.

6. For frock sleeves, align long edges of one sleeve with right sides facing; stitch seam. Turn. Stitch narrow hem on bottom. Repeat for second sleeve. Do not attach sleeves to frock. Set aside.

7. For coat, zigzag raw edges of all pieces. With right sides facing, stitch shoulder seams. Fold seam allowance to wrong side along outside raw edges; topstitch. Stitch narrow hem on bottom. Glue three 6" strips of curly fur along coat front edges and collar; see photo. Set aside.

8. For coat sleeves, complete Step 6 with coat sleeve pieces. Set aside.

9. For hood, stitch top and back seams with right sides facing. Stitch narrow hem along front. Glue 10" piece of curly fur along hemmed edge. Do not attach hood to coat. Set aside.

10. For bag, align short raw edges of bag body with right sides facing; stitch seam. With right sides facing, stitch bag bottom to body, leaving a small opening. Turn. Pull one 18" suede leather strip through opening and through top; tie loose ends together for shoulder strap (see Diagram B). Set aside.

11. For satchel, cut small slit in center of rounded end about ¼" from raw edge. Cut slit in center of square end ½" from raw edge. Fold square end 2" from bottom and, with wrong sides facing, topstitch (see Diagram C). Tie a knot in one end of 2" suede leather length; pull free end through bottom slit, then through top slit and tie a knot. Slip second 18" suede leather strip through and under satchel flap; tie loose ends together for shoulder strap (see Diagram D). Set aside.

12. To make body, hold driftwood vertically. Starting 2" from bottom of driftwood, glue three 7" twigs to front, three to back and one to each side. Glue walnut head to top of driftwood. Glue small piece of gray fur on walnut just under nose for beard and large piece to top for hair. Pull purple frock over head and body.

13. Glue 3" twig to 2" twig, making an L shape for arm. Insert twig arm into purple frock sleeve piece; glue raw edge of sleeve around top of arm. Glue coat sleeve at raw edge over frock sleeve. Glue sleeved arm to driftwood about 1" below head. Make sure raw shoulder edge on frock rests over top of arm and sleeves. Repeat with remaining twigs and sleeve pieces.

14. Position hood on head; glue bottom raw edge to twig body in back under frock. Place coat over frock and sleeves. Wrap 28" suede leather strip several times around waist and tie for belt, leaving 4" tails. Hang satchel from left shoulder.

15. Slip bag strap around body, with bag to back and strap going under left arm and over right shoulder. Re-tie knot in strap to tighten as needed. Bunch together wheat, berries and rattan palm; secure with wire at bottom. Glue bunch into bag. Place collar-shaped fur piece over shoulders.

16. Wrap one 10" suede leather strip tightly around and through tongs of fork; tie and trim ends. Wrap remaining 10" suede leather strip tightly around top 2" of fork handle; tie and trim ends. Set aside.

17. Glue wheat, berries, rattan palm and pinecones to left side of oak base; see photo. Glue Harvester to right side of base. Glue fork to end of left arm.

Diagram A 1 square equals 1"

Diagram B

←Opening

Cut Slit ¼"
From Edge

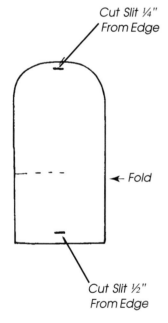

←Fold

Cut Slit ½"
From Edge

←Topstitch

←Folded Edge

Diagram C

Face

←Tie With 2" Strip

Diagram D

118

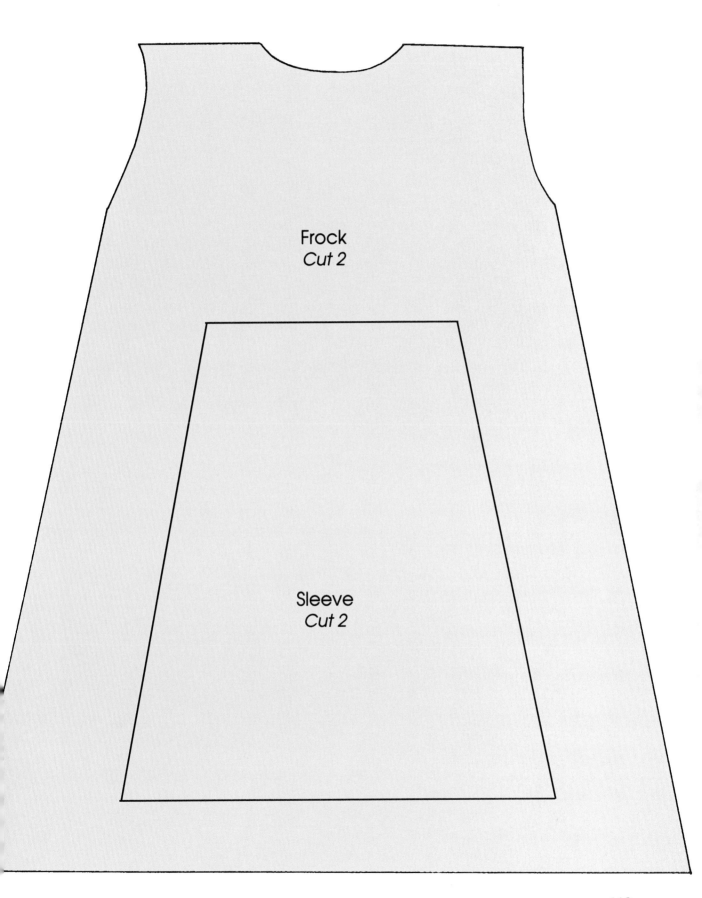

Frock
Cut 2

Sleeve
Cut 2

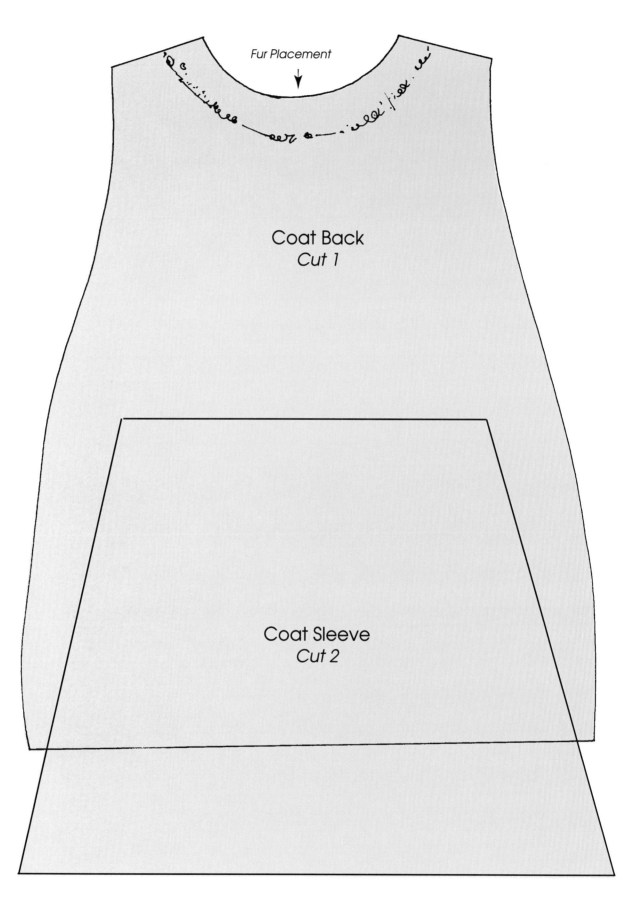

Fur Placement

Coat Back
Cut 1

Coat Sleeve
Cut 2

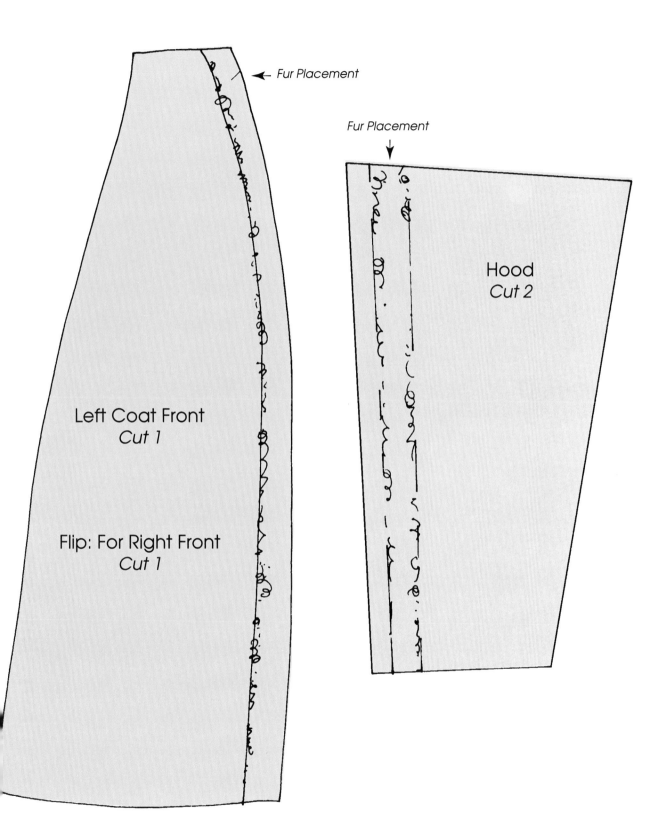

← *Fur Placement*

Fur Placement

Left Coat Front
Cut 1

Flip: For Right Front
Cut 1

Hood
Cut 2

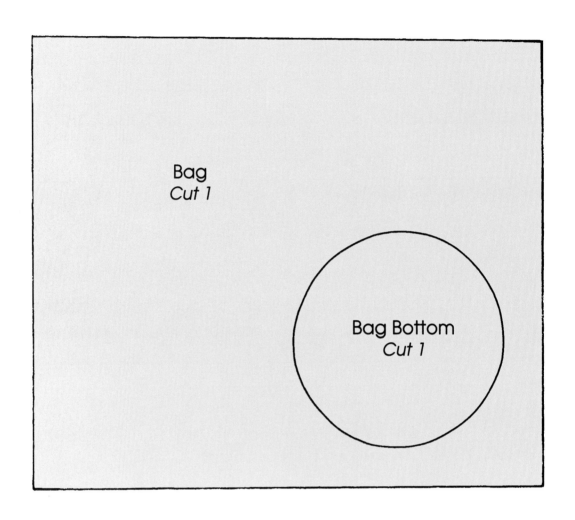

Bag
Cut 1

Bag Bottom
Cut 1

Satchel
Cut 1

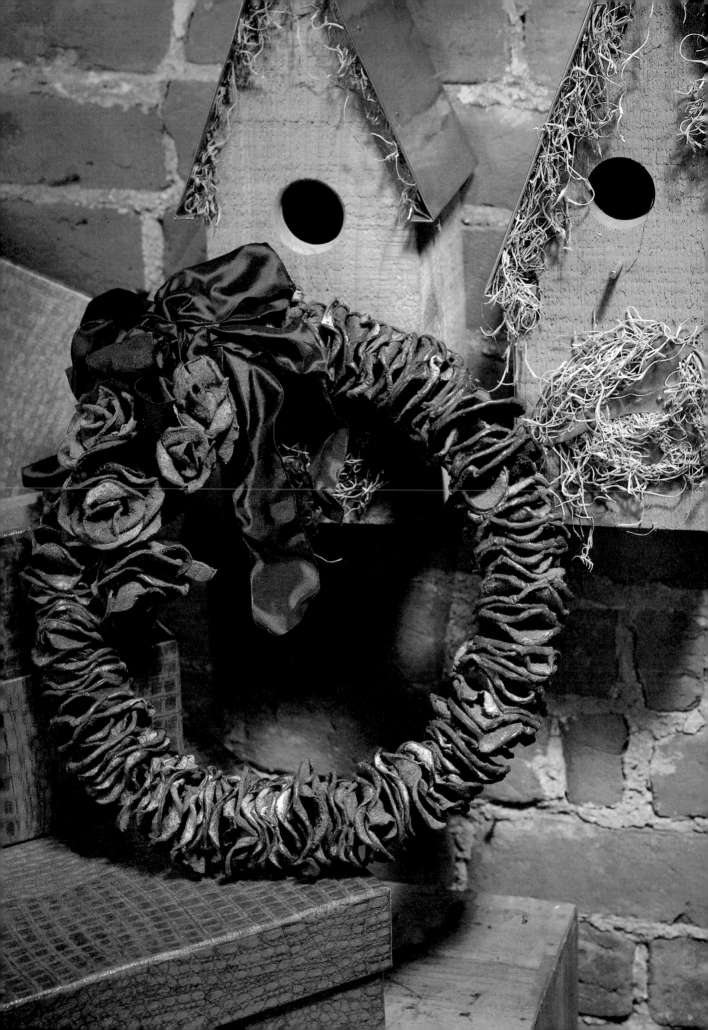

Apples and Cinnamon

Page 123

200 purchased dried apple chips

Cinnamon

Clothes hanger or heavyweight craft wire

Spray bottle of water

Cookie sheet

Pliers

Florist's wire

Florist's tape

1. Mist apple chips with water, sprinkle with cinnamon, place in warm oven until dry. Repeat with other side of chips.

2. With pliers, cut clothes hanger at neck of hook. Shape remaining hanger into a circle. Straighten hooked ends of round frame with pliers. Or, make a 10" circle using heavy craft wire; hook ends together.

3. Thread apple chips on frame until completely covered; see photo. Using pliers, bend ends of wire to make hooks; reconnect to close wreath.

4. To make one apple rose, roll one chip to form center by overlapping ends ¼". Stagger twelve chips around center at overlapping intervals. Wrap florist's tape securely around bottom of rose. Then wrap florist's wire around tape to secure, leaving long ends for attaching.

5. Repeat Step 4 to make five roses. Also make two rosebuds using seven chips per bud. Return roses to warm oven until dry. Attach roses and rosebuds to wreath with wire; see photo.

Country Fruit Bowl

Plastic apple, pear, lemon, lime, peach, orange and plum

25 plastic blueberries

Six plastic cherries

Four plastic strawberries

Plastic grape bunch

Silk leaves

¼ yard red gingham fabric

¼ yard green gingham fabric

¼ yard yellow gingham fabric

¼ yard green/black plaid fabric

¼ yard peach fabric

¼ yard pale orange gingham fabric

¼ yard purple/blue print fabric

¼ yard blue/yellow print fabric

¼ yard red floral print fabric

¼ yard red/white pindot fabric

¼ yard purple fabric

6" square of green felt

1 yard ¼" jute rope

Tacky glue

Strawberry Top

1. Tear red, green, yellow, green/black, peach, orange and purple/blue pattern fabrics into ¾" x 45" strips. Tear blue/yellow, red floral, red/white pindot and purple fabrics into ⅜" x 45" strips.

2. Wrap fruit with fabric strips (one fruit type to one color in order listed), gluing and cutting as needed.

3. Cut 1" stars out of green felt according to pattern; glue onto tops of strawberries. Cut six 6" lengths of rope; glue onto tops of cherries. Glue silk leaves to apple, pear, lemon and grape bunch.

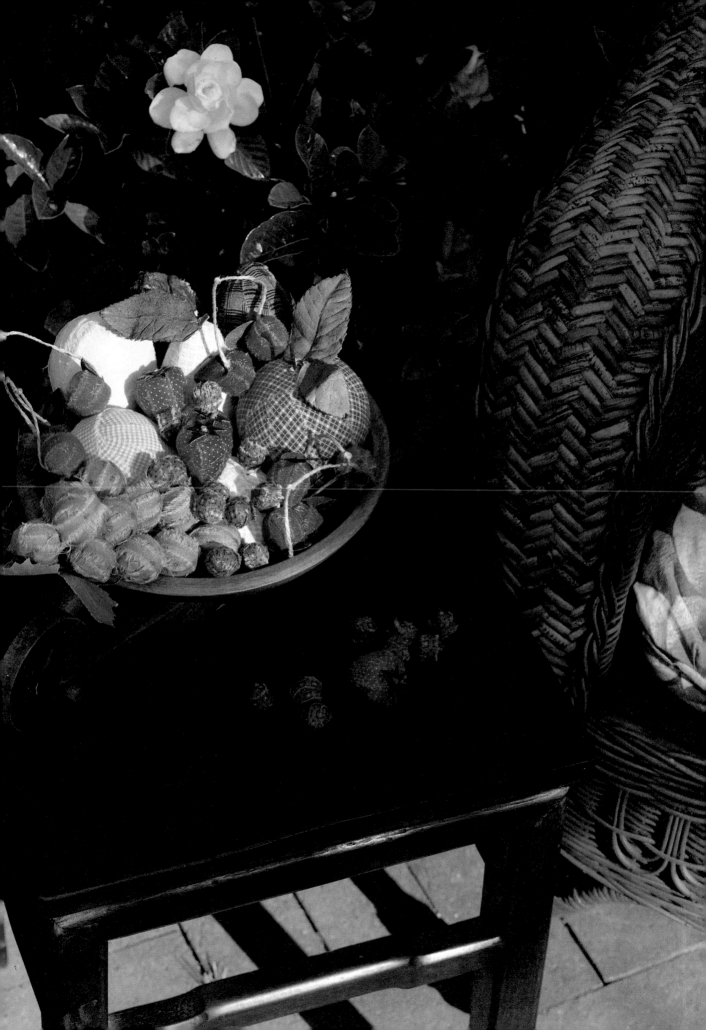

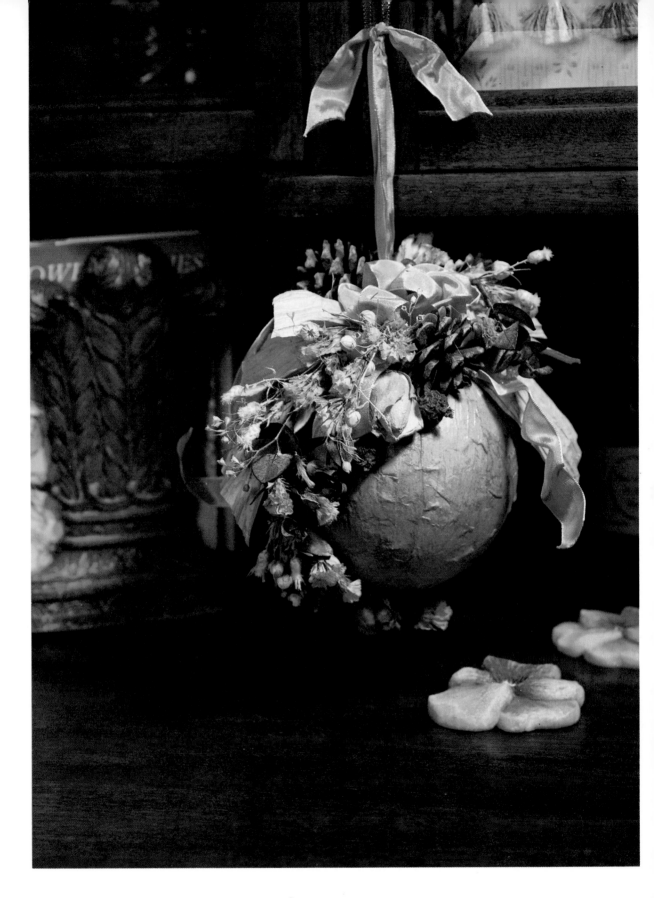

Fantasy Ball

12½" craft foam ball

1¾ yards of 3" tan paper ribbon

2¾ yards of ⅝" pink wired ribbon

Four aqua eucalyptus sprigs

Dried pink statice

Dried yellow happy flowers

Dried mauve berries

Three dried peach rosebuds

Two small pinecones

Thin craft wire

Papier-mâché

Hot glue gun and glue sticks

1. Unravel paper ribbon. Cut into three 12½" lengths, one 10" length, one 7" length and one 4½" length. Cut pink wired ribbon into two 42" lengths and one 12" length. Cut eucalyptus into one 10" and three 6" lengths.

2. Papier-mâché one 12½" length of paper ribbon to foam ball. Wrap ribbon around ball, starting and ending at central point. Repeat with second and third 12½" paper ribbon lengths, overlapping previous ribbon and covering ball. Allow to dry.

3. For paper ribbon bow, cut each end of remaining paper ribbon strips at a slight angle. Twist each strip in center once. Stack twisted pieces with largest piece on bottom and smallest on top. Secure together with craft wire. Glue center of paper ribbon bow to top of ball. Pull ends gently to drape over ball; see photo.

4. Glue 6" eucalyptus sprigs to top center of ball, spacing evenly. Glue 10" sprig to top center so that it hangs freely and rounds down one side; see photo. Glue statice, happy flowers and berries as desired.

5. To make bow, form ten 1½" loops with one 42" pink ribbon, leaving 6" tails. Secure bow loops with craft wire. Glue to top of ball near side of paper bow. Repeat with second 42" ribbon, but make a loop with wire after securing bow. Glue bow to other side of paper ribbon. To make hanger, tie middle of 12" ribbon to wire loop. Bring loose ends together and tie into a knot, leaving 2" tails.

6. Glue one pinecone and one rosebud to center top of paper ribbon and between pink bows. Place remaining pinecone and rosebuds as desired.

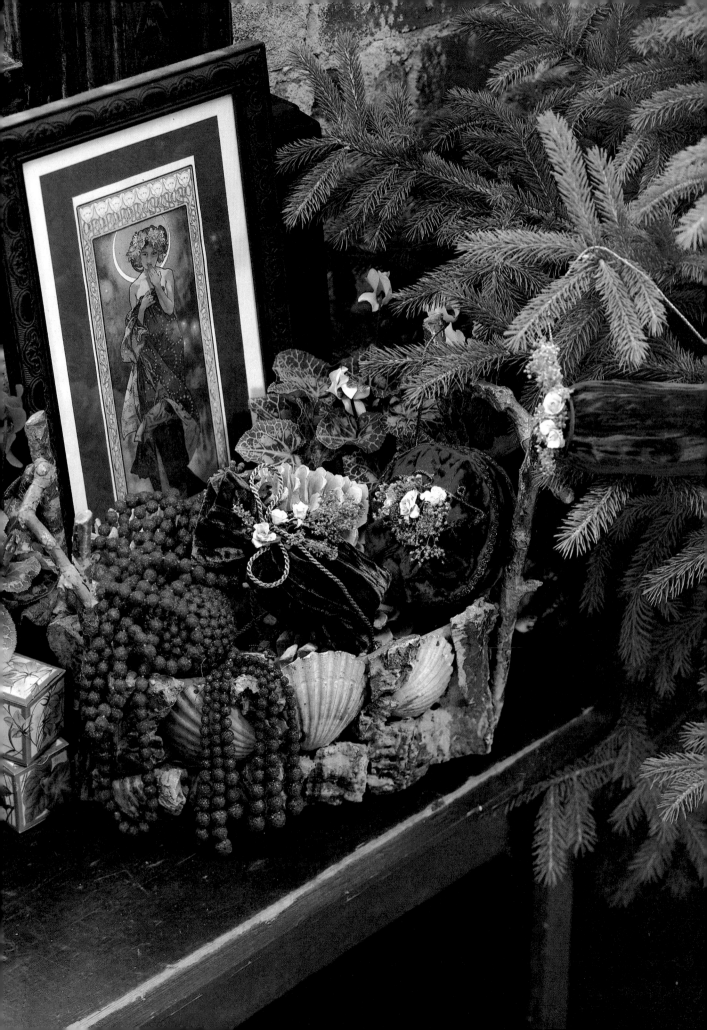

Stylish Sachets

¼ yard antique-green stressed velvet;
matching thread

¼ yard antique-blue stressed velvet;
matching thread

¼ yard antique-red stressed velvet;
matching thread

13" small satin blue corded piping

½ yard of ⅛" gold metallic cord

1½ yards of ⅟₁₆" gold metallic cord

¾ yard of gold trim

Nine dried small white roses

Dried purple flowers

Baby's breath

Potpourri

Polyester stuffing

Hot glue gun and glue sticks

1. Cut ⅟₁₆" gold metallic cord into four 12" lengths. Cut gold trim into two 13½" lengths. From green velvet, cut 9" x 8" piece. From red velvet, cut 13" x 1½" strip and two 13" x 2" strips. From blue velvet, cut one 5½" x 7" piece and two 2" circles.

2. To make sachet bag, fold green velvet with right sides facing; stitch long edges and bottom seam. To square bottom of bag, pull out corners and stitch 1" along each side (see Diagram). Trim corners. Turn.

3. Fold top edge down 3½" to inside. Fill with stuffing and potpourri. Tie 18" length of ⅛" gold cord into a bow around bag. To make hanger, tie 12" length of ⅟₁₆" gold cord around bag, then tie free ends into knot.

4. To make gathered pillow, fold red velvet 1½" strip with right sides facing and short edges together; stitch (see Diagram). Repeat with 2" strips. With right sides facing, stitch one 2" strip to one long edge of 1½" strip. Repeat with remaining 2" strip. Glue gold trim in-the-ditch on both sides of 1½" strip.

5. Sew gathering threads along long raw edges. Gather pillow back to close; tie a knot. Through open front, fill pillow with stuffing and potpourri. Gather front and tie a knot to close.

6. Fold one 12" length of ⅟₁₆" cord in half and tie a knot to make hanger. Stitch knot to pillow as desired on 1½" strip. Glue another 12" length of ⅟₁₆" gold cord to front of pillow, twisting and gluing as desired. Glue dried flowers, baby's breath and three roses to front.

7. To make bolster pillow, stitch blue piping to each end of 5½" x 7" fabric piece. With right sides facing, stitch 2" circles to ends. Also stitch along long edges, leaving an opening. Turn. Fill with stuffing and potpourri. Slipstitch opening closed.

8. To make hanger, tie knot in each end of 12" length of ⅟₁₆" gold cord. Stitch one knot to each pillow end. Glue dried flowers and roses to pillow ends and along hanger.

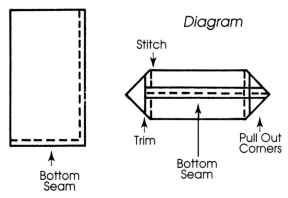

Diagram

Bottom Seam

Stitch

Trim

Bottom Seam

Pull Out Corners

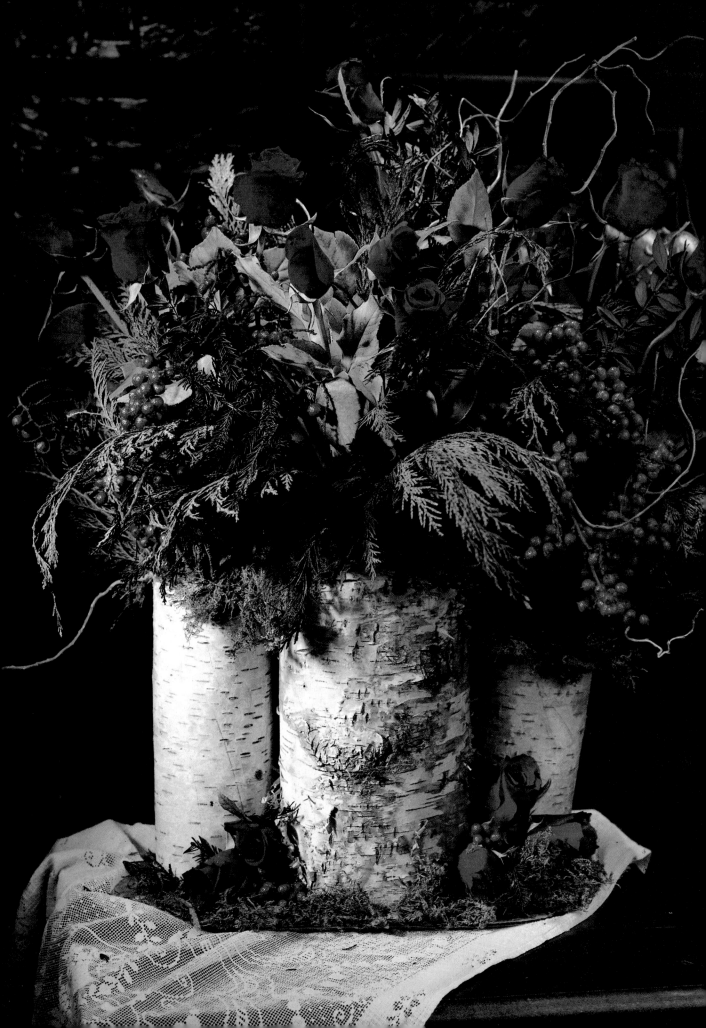

Winter Bark Bouquet

6" x 8" hollow birch trunk

Two 4" x 8" hollow birch trunks

Florist's foam

Three vases to fit inside bark trunks

12" square of heavy cardboard

Sheet moss

Fourteen 10"-14" dried cedar fronds

Eleven 10"-14" dried boxwood fronds

Nine 8"-12" dried pine fronds

Ten 8"-12" canella berry fronds

Nine 12"-14" corkscrew willow branches

1 dozen fresh red roses

Hot glue gun and glue sticks

1. Purchase hollow birch trunks from florist or cut trunk sizes needed and soak in water overnight. Hit wood with hammer to separate bark from tree. Allow bark to dry.

2. Cut florist's foam in tall circle to fit snugly inside birch trunk. Place one overturned vase on top of florist's foam. Trace around glass with a pencil. Cut hole in foam just slightly inside mark. Place foam inside trunk. Push vase into hole. Repeat with remaining trunks and vases.

3. Trim square corners from cardboard to create a free-form base. Place trunks side-by-side with largest one in center. Glue to base.

4. Glue moss and canella berry sprigs on cardboard base. Also glue moss lightly at top edge of trunks.

5. Insert cedar fronds, boxwood fronds, pine fronds, canella berry fronds and corkscrew willow fronds into foam of all trunks. Fill vases with water and insert fresh roses. Add some roses to base; see photo.

Christmas Cardinals

Page 132

24" pine branch

6" piece of ½" plywood

Silk pine on wire branches

Three red craft cardinals

Large craft bird nest

Red raffia

Several large pinecones

Silk leaves

24 small pinecones

Red plastic berries

Dried red pepper berries

Dried lavender berries

Baby's breath

Whole chestnuts

Sheet moss

Two flathead screws

Hot glue gun and glue sticks

1. Cut 24" piece of pine branch that is as straight as possible. To make base, drill two flathead screws through bottom center of plywood and into wide end of pine branch.

2. Drill holes at random into branch. Glue wired silk pine into holes. Arrange birds and nest on tree. Weave raffia around tree. Glue large pinecones and silk leaves to tree, filling in hollow spots. Glue pinecones, berries, baby's breath and chestnuts to tree.

3. To make pinecone star, glue five small pinecones together; see photo. Decorate with baby's breath and berries. Glue to top of tree.

4. Glue sheet moss to plywood and to lower part of tree. Add berries, pinecones and baby's breath.

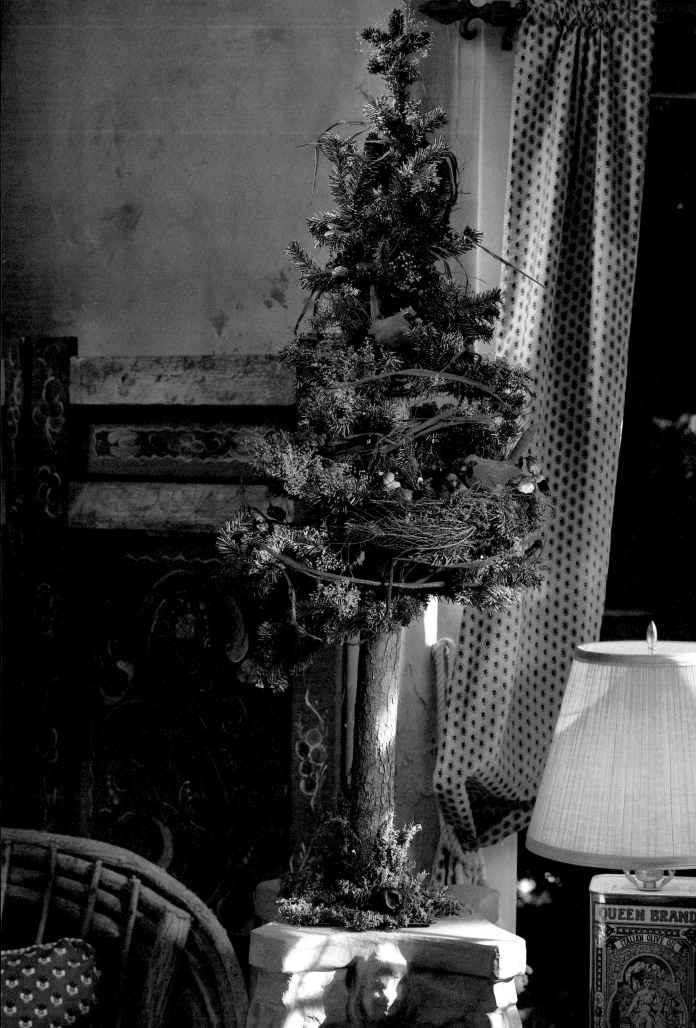

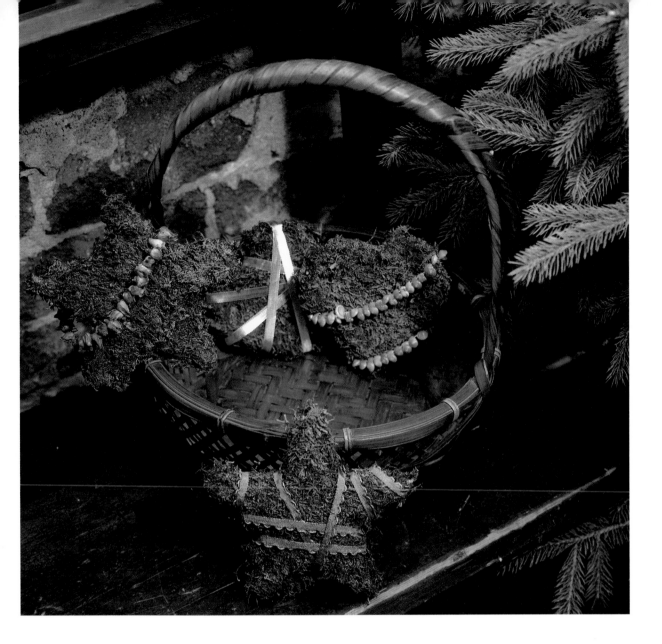

Moss Ornaments

Two 5" craft foam hearts

Two 6" craft foam stars

Sheet moss

1 yard of ¼" gold metallic ribbon

1 yard of ¼" gold-trimmed green ribbon

Assorted small seashells

Dried baby red rosebuds

10-pound fishing line

Needle and thread

Hot glue gun and glue sticks

1. Glue moss to craft foam shapes. Make small holes in seashells with needle; string shells on thread. String rosebuds on thread. Wrap seashells, rosebuds and ribbons around moss-covered shapes; see photo.

2. To make hanger, knot fishing line on needle and pull line through craft foam shape; make loop, pull line back through and secure.

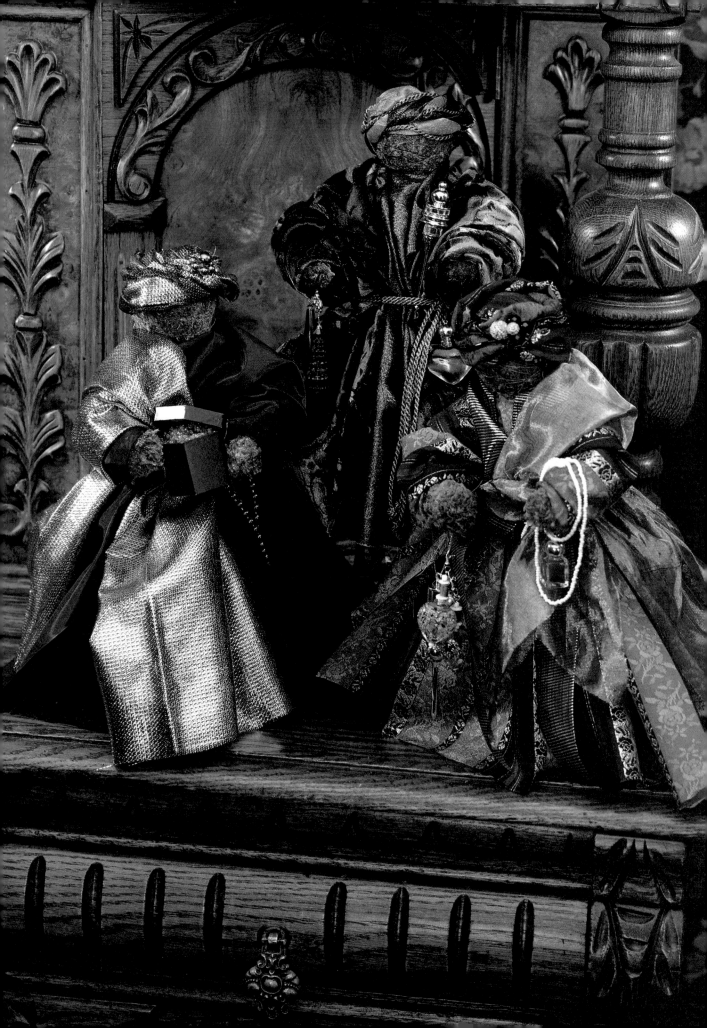

Jeweled Wisemen

Velvet Coat Wiseman

3" craft foam ball

12"-high craft foam cone

1 yard mediumweight craft wire

Sheet moss

10-pound fishing line

¾ yard bronze metallic fabric

20" square of floral print velvet

20" of 3" peach organdy ribbon

2 yards of ⅛" gold metallic cord

Three jeweled ornaments

Rubber band

Straight pins

Tacky glue

1. Cut 2" from bottom of cone. Cut craft wire into one 10" length and one 26" length. Push 2" of 10" wire into bottom of ball. Apply tacky glue to secure wire. Allow to dry. Push free length of wire into top of cone. Apply tacky glue between cone and ball; push together. Allow to dry.

2. To make shoulders and arms, push 26" wire horizontally through cone about 1" from top. Bend free ends into horseshoe shapes and secure back into cone (see Diagram A). Shape arms as desired.

3. Wrap sheet moss over cone body, covering thoroughly. Secure fishing line at top of cone over moss. Pulling tightly, wrap line over moss and around cone from top to bottom and back again until moss is formed against cone; see photo. Repeat to cover head and arms with moss.

4. Cut bronze metallic fabric into 20" square and 3" x 20" strip. To make frock, fold 20" square into quarters. Cut circle from middle to fit over head (see Diagram B). Fold and glue fabric around neck and arms, allowing hands to show. Wrap rubber band over material around waist.

5. To make coat, cut 20" square of velvet (see Diagram C). Wrap fabric around neck with inside raw edges to front. Fold under raw edges, then wrap and glue fabric around arms, allowing hands to show. Cut gold cord into three 24" lengths. Tie two lengths around waist; knot ends.

6. Twist 3" x 20" piece of bronze metallic fabric, 3" x 20" strip of peach organdy ribbon and remaining 24" length of gold cord together. Wrap twisted fabric and cord around head; secure with straight pins.

7. Glue one ornament in crook of left arm. Hang two from right arm; glue.

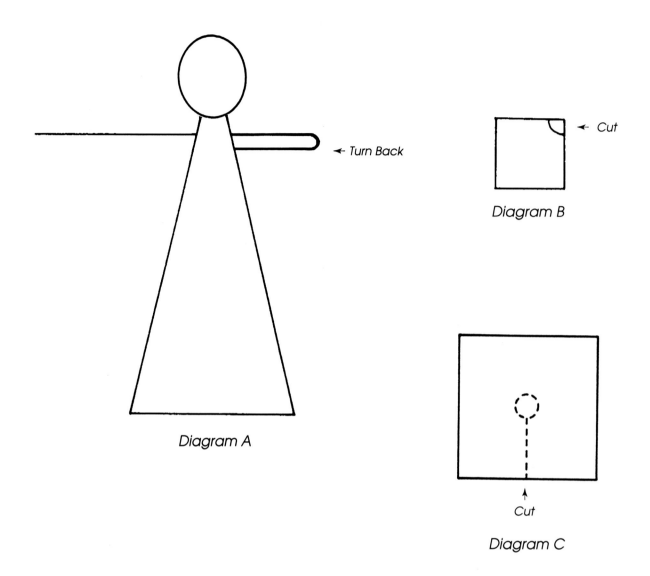

← Turn Back

Diagram A

← Cut

Diagram B

Cut

Diagram C

Red Taffeta Wiseman

First five materials from Velvet Coat
 Wiseman on page 135
20" square of red taffeta
20" square of pink brocade
1 yard strand of green metallic beads
Loose green metallic beads
Small blue craft box with lid
Loose miniature gold beads
Cotton ball
Rubber band
Straight pins
Tacky glue

1. Complete Steps 1-3 of Velvet Coat
Wiseman. With 20" square of red taffeta,
complete Step 5, using rubber band at waist
and omitting gold cord.

2. Cut 20" square of pink brocade in half.
Fold and drape one half over right shoulder.
Wrap and tie green bead strand around waist
to secure brocade. Fold, twist and wrap
remaining brocade around head; secure with
straight pins. Glue loose green beads on
fabric hat as desired.

3. Glue cotton ball in box. Glue loose gold
beads on top of cotton. Glue lid open to
back of box. Glue box to hands.

Gold Ribbon Wiseman

First five materials from Velvet Coat
 Wiseman on page 135
¾ yard of plaid metallic fabric
¾ yard of 2" gold metallic ribbon
1 yard of 5" avocado organdy ribbon
¾ yard strung black bugle beads
Three black beads
Two gold beads
¾ yard strung miniature white beads
Four jeweled ornaments
Rubber band
Straight pins
Tacky glue

1. Complete Steps 1-3 of Velvet Coat
Wiseman. Cut plaid metallic fabric into 20"
square and 3" x 20" strip. With 20" square of
plaid metallic fabric, complete Step 5, using
rubber band at waist and omitting gold cord.

2. Cut ends of gold metallic ribbon at slight
angle. Wrap ribbon around neck, allowing
tails to fall evenly between arms. Cut a "V"
from ends of organdy ribbon. Wrap organdy
around neck and tie under right arm. Tie
again around waist for belt, securing gold
metallic ribbon against frock.

3. Twist 3" x 20" piece of plaid metallic
fabric around head; secure with straight pins.
Wrap and glue black bugle beads around
fabric hat. Glue black and gold beads on hat
as desired.

4. Loop white beads three times and secure
on left arm with straight pin; see photo.
Hang one ornament from left arm and three
from right arm; glue.

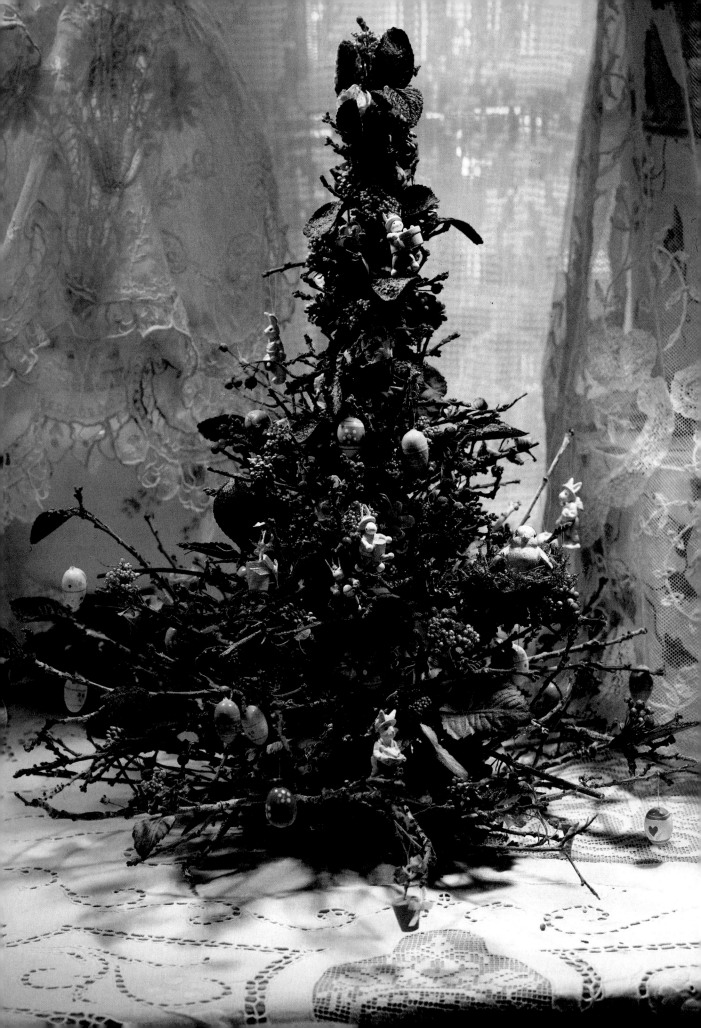

Easter Attraction

50 2–10"-long twigs

19" heavyweight craft wire

Small pinecones

Dried pink rosebuds or silk roses

Dried flowers: pink, blue and lavender

Green velvet leaves

Green silk leaves

Sheet moss

Ceramic chick in egg

Miniature Easter ornaments

Acrylic paints: pink, blue and lavender

Paintbrushes

Hot glue gun and glue sticks

1. Paint pinecones with desired color of acrylic paints. Allow to dry.

2. Glue ends of about 30 larger twigs together to form tree base. Insert craft wire vertically in center of twig base. Continue gluing twigs, attaching them to wire. Use graduating sizes of smaller twigs horizontally and with an upward slant. Bring smallest twigs together vertically to form tree top.

3. Glue pinecones, flowers, roses and leaves to tree; see photo. Shape moss into a small nest. Glue on one lower branch. Glue ceramic chick to middle of nest. Hang ornaments on tree.

Bird of Paradise

Page 140

Purchased topiary bird in clay pot
 (see Suppliers)

¾ yard of ⅛" peach satin ribbon

¾ yard of 1" yellow/peach wired ribbon

Dried baby red rosebuds

Forest green acrylic paint

Paintbrush

Hot glue gun and glue sticks

1. Topiaries can be found in many shapes and sizes. To find this topiary, see Suppliers on page 159.

2. Water paint down to consistency of ink. Paint moss on bird and in clay pot. Allow to dry.

3. Cut satin ribbon into one 11" length and one 20" length. Glue rosebuds onto ribbons, leaving 1" on each end uncovered. Wrap short ribbon around topiary bird's neck and long ribbon around pot. Glue overlapped uncovered ends together. Add more rosebuds to cover ribbon.

4. Shape wired ribbon on topiary, gluing at points to secure.

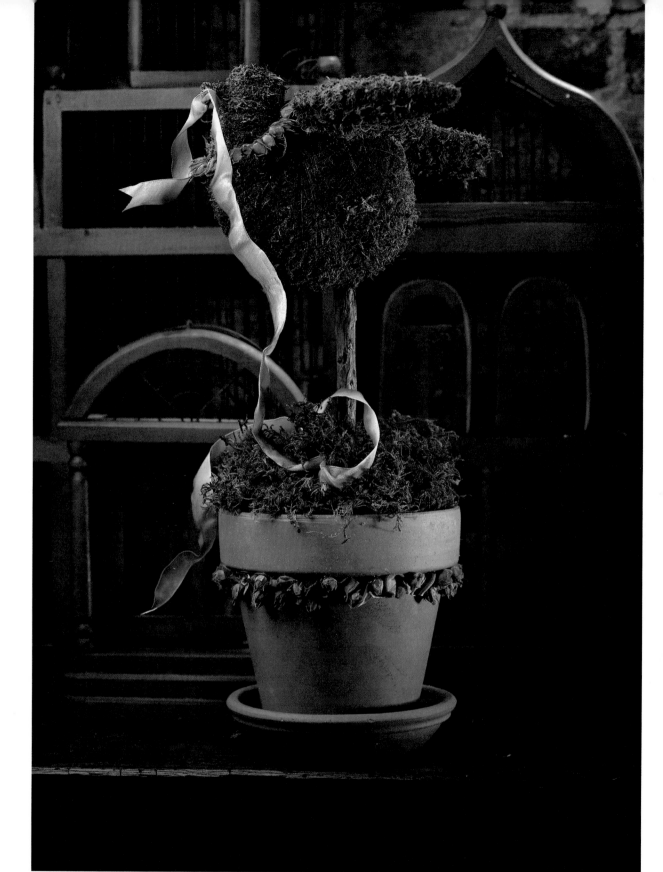

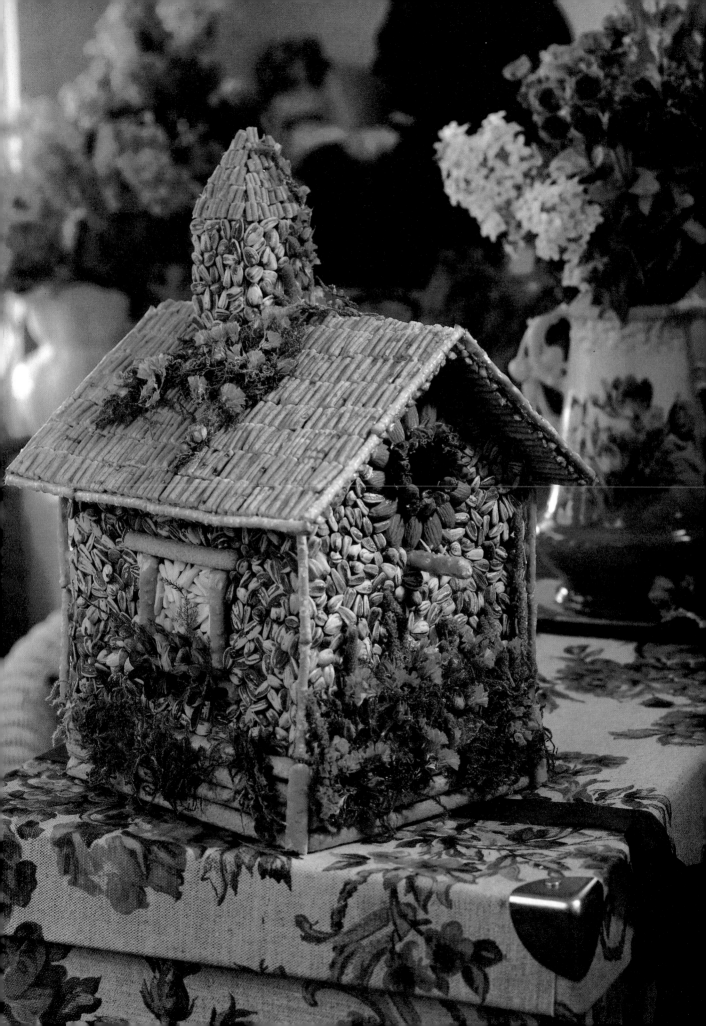

Feathered-Friend Retreat

Page 141

16" x 20" sheet of mat board

1 cup sugar

½ cup light corn syrup

¼ cup water

Seventeen ½" x 8" breadsticks

Pretzel logs and sticks

Whole and slivered almonds

Sesame nuts

Sunflower seeds in shell

Sheet moss

Dried baby pink rosebuds

Dried boxwood leaves

Dried plumosa fern

Dried pink statice

Dried purple rattail statice

Craft knife

White utility tape

Hot glue gun and glue sticks

1. Trace and transfer patterns onto mat board. Cut out front, back, two sides, two roofs and four steeple pieces. Mark opening and roost placement on front; cut out. Mark window placement on sides; do not cut out.

2. Score roof lines on steeple pieces. To score, cut lightly along line on right side of piece with craft knife; do not cut through completely.

3. Tape front, sides and back together on outside, matching letters. On each seam inside, run a thin line of glue. Tape roof pieces together on C edges. Center on top of house; glue seams. Tape steeple together. Bend on score lines to make point; tape. Glue seams. Insert steeple into roof opening; glue.

4. Combine sugar, corn syrup and water in saucepan. Boil at 227°. Using mixture as if it were glue, attach four breadsticks horizontally and parallel to each other along bottom left side of birdhouse. Repeat on right side. Cut eight breadsticks to 7". Attach four, horizontally and parallel, to bottom front and four to back. Cut last breadstick into four 2" pieces. Attach short pieces vertically at bottom corners.

5. On sides, attach pretzel logs along window placement marks. Fill in window with slivered almonds. On front, fit pretzel log in small hole for roost. Attach whole almonds around front opening.

6. Attach sesame nuts to roof and to steeple roof. Attach sunflower seeds to cover bare areas on front, sides, back and steeple. Attach pretzel stick pieces under eaves. Attach pretzel sticks to outline roof and house corners; see photo.

7. Attach rosebuds around opening on front. Attach boxwood leaves, fern and roses to bottom of windows. Attach moss, partially covering breadsticks, along bottom of house. Attach moss as desired on roof and steeple. Attach rosebuds, pink statice and purple rattail statice on top of moss in front and on roof; see photo.

Cut From Front Only

A

B

Cut 1 Front

Cut 1 Back

143

Roof
Cut 2

D

C

Steeple
Cut 4

Sides
Cut 2

Window
Placement

B

D

A

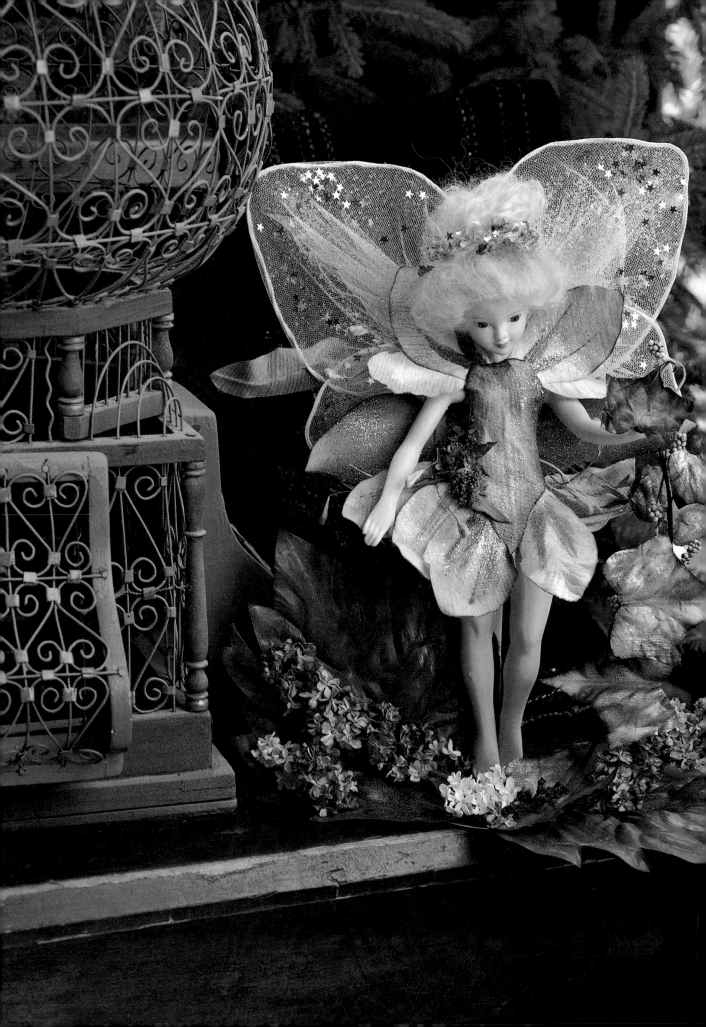

Fanciful Flower Fairy

Porcelain fairy doll (see Suppliers)
Porcelain doll stand
Two silk lavender flowers with 2" x 3" petals
Five 2" x 3½" silk green leaves
Two 1" x 7" silk green leaves
Bunch lavender flower centers
Small dried purple flowers
¾ yard bridal netting
Dried lilacs: white and lavender
Two 6" x 9" silk green leaves
Strand silk ivy
Small silk green berries
Florist's wire
Fine pearlescent glitter
3 yards white craft wire
Fine powder glitter: pink and gold
Confetti stars
Acrylic paints: purple and gold
Paintbrushes
Tacky glue

1. Assemble doll. Pull apart silk flowers. Cut florist's wire into fourteen 3" lengths, two 3½" lengths and two 7" lengths. Glue 3" lengths to back of flower petals, 3½" lengths to two short leaves and 7" lengths to long leaves.

2. Dilute tacky glue with water to consistency of ink. Brush glue on front of petals and sprinkle with pearlescent glitter. Repeat on all leaves. Allow to dry. Set aside.

3. To make wings, cut white craft wire into four 14" lengths, four 10" lengths and one 12" length. Cut bridal netting into two 14" square pieces and two 10" square pieces.

4. Twist two 14" wire lengths together to make thick wire. Form into large wing shape according to pattern. Twist ends together.

Wrap bridal netting over wire; pleat and pinch at point where wire ends meet. Tighten netting and secure with craft wire. Repeat, making another large wing and two small wings. Secure four wings together with craft wire. Brush netting with glue and sprinkle with stars. Brush on pink powder glitter. Set aside.

5. To dress fairy, wrap small leaf between legs and glue. Glue ten flower petals around waist to form skirt; see photo. Glue two petals at each shoulder for sleeves. Place one 3½" non-wired green leaf at bodice with point coming down onto skirt. Glue dried purple flowers at left hip. See photo.

6. On back, glue wire ends of flower centers to mid-back and between shoulders, allowing flower centers to fan out. Bend them slightly to front. At mid-back, glue two 3½" wired leaves horizontally, covering flower center ends. Leaf ends should meet mid-back. Glue center of wings just below neck at back. Glue two 7" leaves meeting in a "V" at mid-back. Glue last 3½" leaf vertically over other leaf ends on back. Shape wired petals and leaves as desired.

7. To make hair garland, glue dried lilacs into a wreath. Brush with diluted glue and sprinkle with confetti stars. Pull hair through wreath; see photo. Set doll aside.

8. Dry brush two 9" leaves and ivy with purple and gold paint. Brush with diluted glue and dust with gold powder glitter. Glue green berries to 10" length of florist's wire. Wrap berry strand through ivy.

9. Glue two 9" leaves to bottom of doll stand. Glue lilacs to leaves. Place doll in stand. Glue end of ivy/berry strand to left bottom of stand and hook other end to fairy's hand.

Wings

Twist Ends

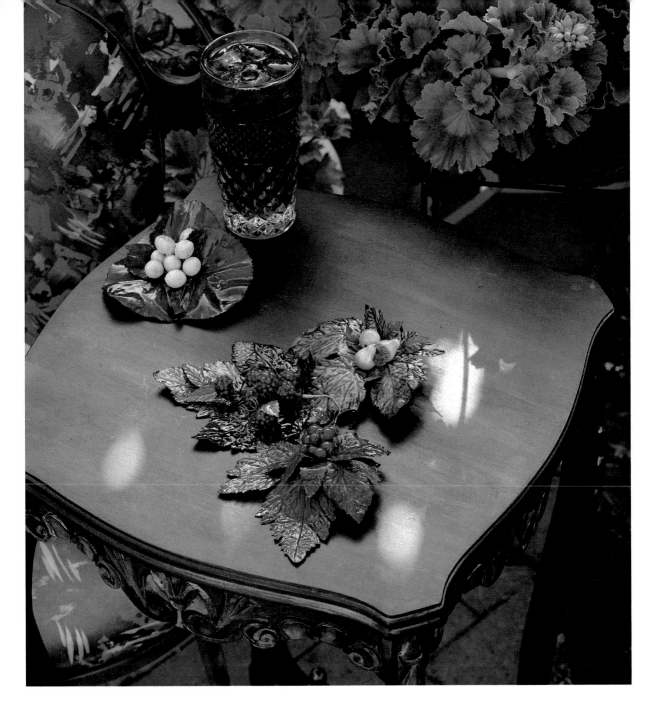

Berry Accents

Twenty small silk leaves
Four large silk leaves
Miniature plastic lemons
Plastic raspberries
Miniature plastic pears
Plastic blueberries
Clear resin spray
Acrylic paints: green and bronze
Paintbrushes
Hot glue gun and glue sticks

Paint small leaves green and bronze. Glue
about five small leaves to center of large
leaf. Glue fruit on top of small leaves. Spray
all with clear resin about ten times, allowing
to dry after each coat.

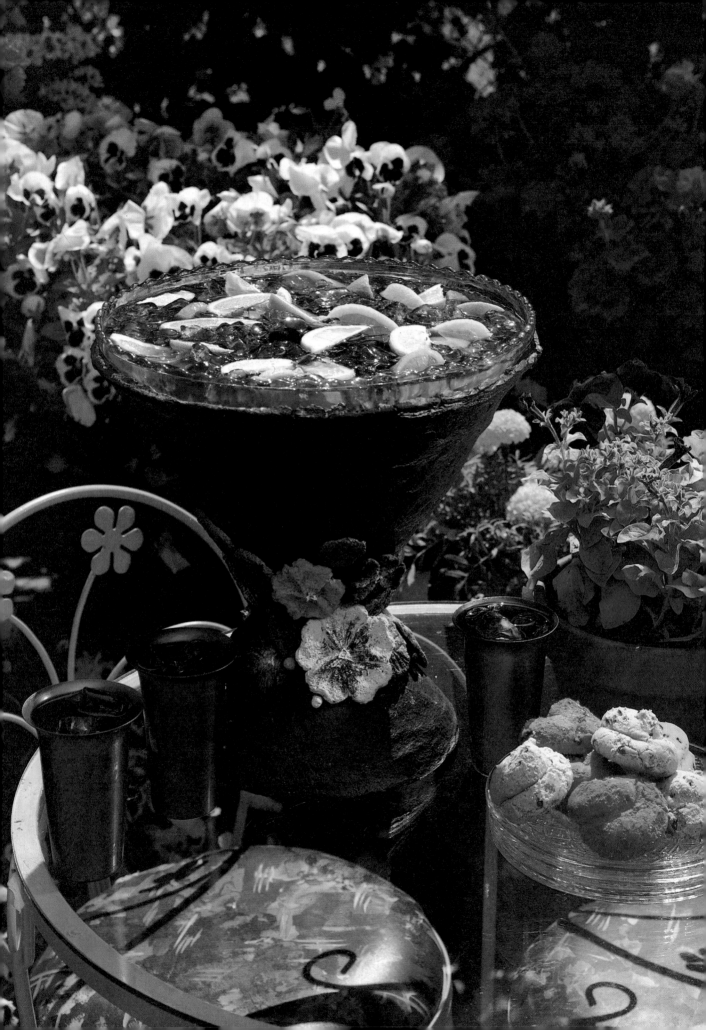

Party Specialty

Glass punch bowl and stand

Clear plastic wrap

Papier-mâché

Acrylic paint: purple, orange, yellow, green,
 dark green and white

Paintbrushes

Hot glue gun and glue sticks

1. Place plastic wrap on outside of punch
bowl. Follow directions on papier-mâché
package. Mold to outside of punch bowl
and stand. Allow two days to dry. Paint
purple. Allow to dry.

2. For flowers, form papier-mâché into heart-
shaped petals according to patterns. Overlap
five petals per flower (see Diagram). Shape
leaves according to pattern. Shape small
balls. Allow to dry. Paint flowers, leaves and
balls; see photo. Glue to purple punch bowl
as desired.

Leaves

Diagram

Petals

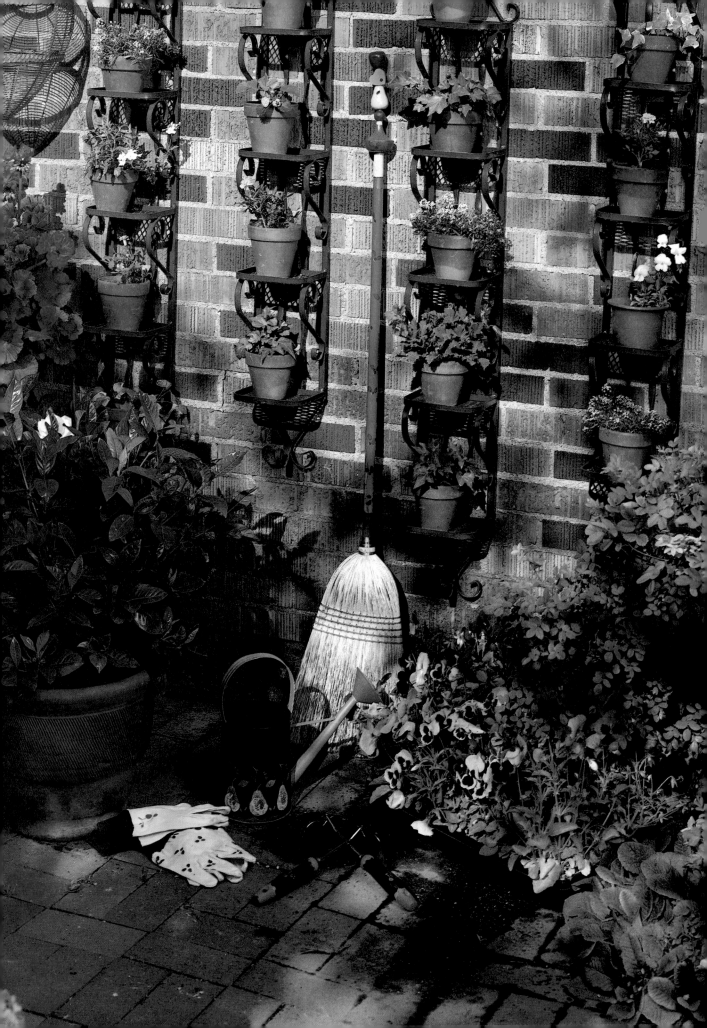

Spruced-Up Tools

Metal watering can

Wood-handled broom

Two wood-handled spades

Two pair canvas gardening gloves

Wood cutouts: 1½" apple, 1" heart, 2" pear,
 1" bead and 3" finial

6½" piece of heavyweight craft wire

Gray metal primer spray paint

Acrylic paints: dark green, lime green,
 purple, lavender, aqua, bright yellow,
 light yellow, red and peach

Manila folder

Tracing paper

Craft knife

Paintbrushes

Black permanent fine-tip marker

Wood glue

1. Trace berry, cherry and pear stencil patterns onto manila folder. Each different colored shape needs a separate stencil. Cut shapes with craft knife. For more on stencils, see General Instructions on page 157.

2. Spray watering can with metal primer paint. Allow to dry. With dark green, paint outside and inside of can body. Paint spout and handle with lime green, aqua and lavender paints; see photo. Allow to dry.

3. Paint aqua border around bottom of can. Position stencils and paint berries red with green leaves. Paint pears green, peach and light yellow with dark green dots. Paint pear stem peach and green. Paint leaves aqua. Paint cherries red with aqua leaves.

4. Paint broom handle purple, green and yellow; see photo. Allow to dry. Use berry stencil on handle, positioning as desired. Allow to dry. Outline berries and leaves with black marker.

5. Paint wood cutouts; see photo. Allow to dry. Drill small hole vertically through finial, bead, pear and heart. Drill small hole about ¾" into bottom of apple. Slightly hook one end of craft wire and insert straight end through finial, bead, pear, heart and into bottom of apple. Using wood glue, glue wood cutouts together where they meet. Insert broom handle into finial; glue.

6. Paint spade handles dark green with lime green and aqua borders on bottom and aqua and lavender borders on top. Position cherry stencil; paint.

7. Position cherry stencil on one pair of gloves above cuff; paint. Position berry stencils on remaining pair; paint.

← Green, Aqua

← Yellow, Green, Peach

Aqua ↓

Cherry

← Red

Pear

Green →

← Red

Berry

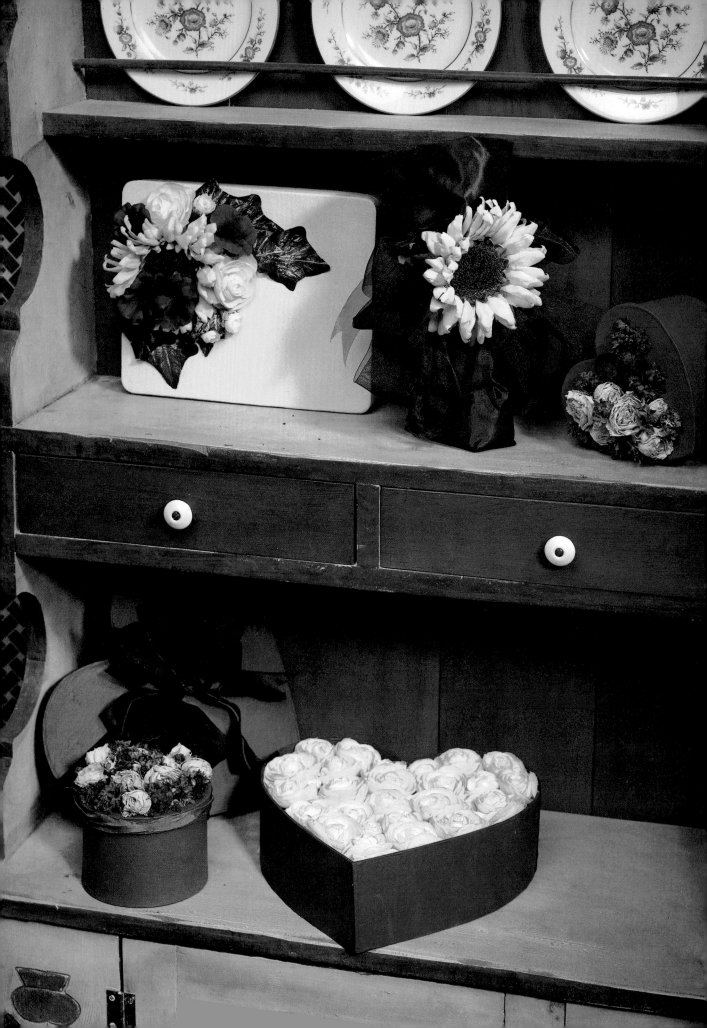

Treasure Keepers

Square Box

7" x 9" box with lid
Strand of silk ivy
Silk sunflower
Two medium silk yellow ranunculus
Three small silk yellow ranunculus
Five silk purple pansies
Acrylic paints: yellow and purple
Paintbrushes
Hot glue gun and glue sticks

Paint box and lid yellow. Allow to dry. Paint yellow and purple accents on ivy leaves. Allow to dry. Glue ivy to box, following upper left corner. Glue sunflower, ranunculus and pansies to box lid; see photo.

Sachet Bag

10" x 14½" piece of green satin;
 matching thread
Potpourri
2 yards of 2" green organdy ribbon
2 yards of 1½" purple organdy ribbon
2 yards of ⅜" purple organdy ribbon
Silk sunflower
Two silk purple pansies
Hot glue gun and glue sticks

1. To make bag, fold piece of green satin, aligning long edges. With right sides facing, stitch side and bottom seams. To square off bottom of bag, see Stylish Sachets on page 129. Double fold top raw edge to inside; topstitch. Fold finished edge down 2" to inside. Fill bag with potpourri as desired.

2. Cut all organdy ribbon into 1-yard lengths. Handling both green lengths as one, tie bow.

Handling both ⅜" purple lengths as one, tie bow. Handling both 1½" purple lengths as one, tie around bag. Tie tails around green and ⅜" purple bows; tie a bow. Glue sunflower and pansies to bow.

Small Heart Box

5" heart-shaped box with lid
Five small dried yellow roses
Dried lilacs
Dried purple statice
7" of ⅜" purple organdy ribbon
Green acrylic paint
Paintbrush
Florist's wire
Hot glue gun and glue sticks

Paint box and lid green. Allow to dry. Glue rose, lilacs and statice to lid; see photo. Make three loops with ribbon and secure with wire. Glue to lid near roses.

Round Box

4" round box with lid
15" of ¾" purple wired ribbon
Ten small dried yellow roses
Dried lilacs
Dried purple statice
Miniature silk purple berries
Green acrylic paint
Paintbrush
Hot glue gun and glue sticks

Paint box and lid green. Allow to dry. Glue ribbon around rim of lid; pinching, gathering and gluing every 2½" until ends meet. Trim excess. Glue roses, lilacs, statice and berries to lid; see photo.

Large Heart Box

10" heart-shaped box (3" deep) with lid
10" square florist's foam (2" deep)
2 yards of 1" green wired ribbon
1 yard of 2" green organdy ribbon
24 medium silk yellow ranunculus
Ten small silk yellow ranunculus
Purple acrylic paint
Paintbrush
Kitchen knife
Hot glue gun and glue sticks

1. Paint box and lid purple. Allow to dry. Place box on florist's foam and trace heart shape. Following just inside lines with kitchen knife, cut florist's foam to fit inside box. Set aside.

2. Cut green wired ribbon into three 18" lengths and two 7½" lengths. Cut green organdy ribbon into three 12" lengths.

3. Glue one 18" length of wired ribbon down sides and across bottom of box, starting 2" from top of heart shape. Fold and glue ribbon ends to inside of box.

4. Cut ranunculus stems about 2" long. Place florist's foam in box. Push ranunculus into foam, covering completely. Use small ranunculus to fill in bare spots.

5. Glue one 7½" wired ribbon length to lid, starting 2" from top of heart shape on left side. Fold and glue ribbon end inside box; angle ribbon down slightly and glue other end to middle of lid. Repeat with remaining 7½" length on right side.

6. Handling three organdy ribbon lengths as one, tie bow. Handling two 18" wired ribbon lengths as one, tie into bow around organdy bow. Glue finished bow to lid, covering wired ribbon ends in middle.

General Instructions

Grapevine Wreaths

Ten 2–5'-long grapevines
Heavyweight craft wire
Garden clippers

To make a round grapevine wreath, gather grapevines. If not fresh, soak vines in water until pliable. Choose four to six lengths. On a work table, place vines together with ends staggered slightly. Bring vine lengths around to form a 15", 18" or 24" circle.

Hold vine ends together with one hand and wrap longest vine around circle, catching shorter vines. Add more vines in same manner for volume. Tuck in stray ends. Clip unsightly pieces.

To make oval wreath, complete instructions for a round wreath but shape into an oval instead of a circle.

To make heart-shaped wreath, shape wreath on work table. Start at top right, making an arch, then shape vines to a point at bottom. Secure bottom point with mediumweight craft wire. Then form another arch at top left. Bring vines together into a heart-shaped point at top; secure with craft wire. Wrap longest vine around heart shape, catching shorter vines. Add more vines in same manner for volume. Tuck in stray ends. Clip unsightly pieces.

Patterns & Stencils

FABRIC PATTERNS: Using tracing paper, trace pattern. Transfer to fabric and cut as directed in project instructions. All patterns include a ¼" seam allowance unless otherwise specified.

STENCIL PATTERNS: Using tracing paper, trace patterns. Transfer to desired surface using carbon paper.

STENCILLING: Trace and transfer designs onto manila folder. Cut design from folder with craft knife. Make one stencil for each color used in design.

Place object to be stencilled on sturdy surface. Position and secure stencil in place with masking tape. Paint stencil design with specified color. Move to next position and repeat process.

If multiple colors are used on part of design, make one stencil, then paint design with main color using that stencil. Remove stencil, then touch up design with additional colors.

If many repeats of same design need to be painted, make more than one stencil for that design. This will provide a fresh, strong stencil when doing multiple paintings.

Ribbon Flowers & Leaves

Use ribbon lengths specified in individual project directions.

LILIES: With one ribbon length, fold ends diagonally across to center and down (see Diagram A). Fold sides across and down again to make lily shape (see Diagram B). Insert purchased flower center. Stitch flower at bottom to secure petals.

LEAVES: Repeat process for making LILIES but do not use flower centers.

ROSES: Fold ribbon in half lengthwise. Twist and roll one short end to make rose center (see Diagram C). Continue twisting and rolling long free tail around center to complete (see Diagram D). Stitch at bottom to secure. If some petals look out of place or start to unfurl, stitch to secure. For rosebud, twist and roll free tail tightly once or twice then stitch to secure; cut excess.

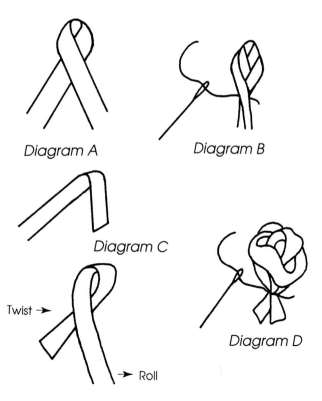

Diagram A

Diagram B

Diagram C

Twist →

→ Roll

Diagram D

Drying Flowers & Leaves

AIR DRYING: Gather loose bunches of six to ten stems and secure with string or elastic band. Hang bunches upside down in spare room, garage or shed. For short-stemmed flowers or leaves, put a window screen on four bricks and lay foliage on screen.

SILICA GEL: These quick-acting, moisture-absorbent crystals can be found at most craft supply stores.

Pour 1" of silica gel into a metal, glass or plastic container. Place flowers and leaves on top, spacing adequately. Cover plants with more crystals. Add another layer of plants, then silica gel, until container is full.

Check plants every other day as silica gel dries quickly. When dry, take flowers from container and use small paintbrush to whisk away lingering crystals between petals.

NOTE: Silica gel must be used to successfully dry peonies, lilacs and daffodils.

MICROWAVE: Using a microwave-safe container, surround plants with thin layer of silica gel on bottom and top. Microwave for one to two minutes on medium. Let stand outside oven for 30 minutes.

DRYING HINT: Fragile grasses, grains, seedpods, flowers and leaves can break during drying unless the surface is sealed. Before drying, spray plant liberally with a fixative, such as hair spray.

Looped Bows

Use ribbon lengths specified in individual project directions.

Leaving a length of ribbon for one tail, make a figure eight with loops of desired size (see Diagram E). Holding ribbon in center with thumb and forefinger, make second figure eight on top of first.

Continue until desired number of loops are formed and leave a second tail. Pinch and gather together center of loops. Wrap and knot craft wire around center to secure. (See Diagrams F and G.)

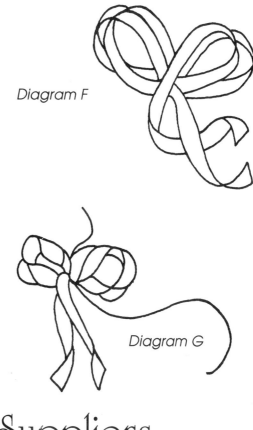

Diagram F

Diagram G

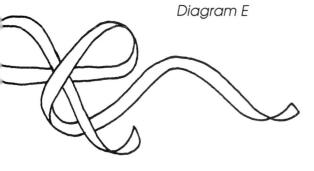

Diagram E

Pressing Flowers

A flower press can be purchased from most craft stores. For a simple way to successfully press flowers, lay blooms between sheets of newspaper. Then place between pages of large, heavy book. Weight book with another heavy object for best results.

For larger foliage or leaves, lay plants between long sheets of newspaper. Place under one corner of heavy carpet where there is not much foot traffic.

Suppliers

For specialty products, write these suppliers for more information:

Topiary Bird
La Bouquetiere
563 Sutter Street
San Francisco CA 94102

Fairy Porcelain Doll
Chapelle Designers
Box 9252 Newgate Station
Ogden UT 84409

No. 7 Jaceron Pearl Wire
Kreinik Manufacturing Co., Inc.
P.O. Box 1966
Parkersburg WV 26102

Index

All of us at Meredith® Press are dedicated to offering you, our customer, the best books we can create. We are particularly concerned that all the instructions for making projects are clear and accurate. We welcome your comments and would like to hear any suggestions you may have. Please address your correspondence to Customer Service Department, Meredith® Press, Meredith® Corporation, 150 East 52nd Street, New York NY 10022.

If you would like to order additional copies of any of our books, call 1-800-678-2803 or check with your local bookstore.